IMAGES
of America

YORKTOWN

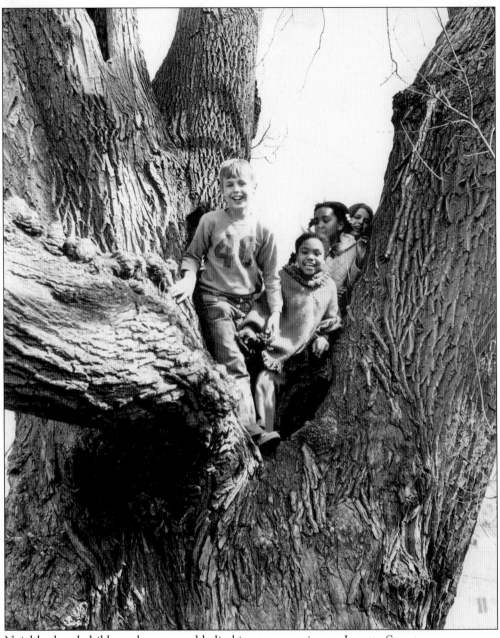

Neighborhood children play on an old climbing tree growing on Loretta Street.

IMAGES
of America

YORKTOWN

Linda Cooper and Alice Roker
with the Town of Yorktown

ARCADIA

First published 2003
Reprinted 2003

Published by Arcadia Publishing,
an imprint of Tempus Publishing Inc.
Portsmouth NH, Charleston SC, Chicago,
San Francisco

Printed in Great Britain

Library of Congress Catalog Card Number: 2003106974

For all general information, contact Arcadia Publishing:
Telephone 843-853-2070
Fax 843-853-0044
E-mail sales@arcadiapublishing.com
For customer service and orders:
Toll-free 1-888-313-2665

Visit us on the Internet at www.arcadiapublishing.com

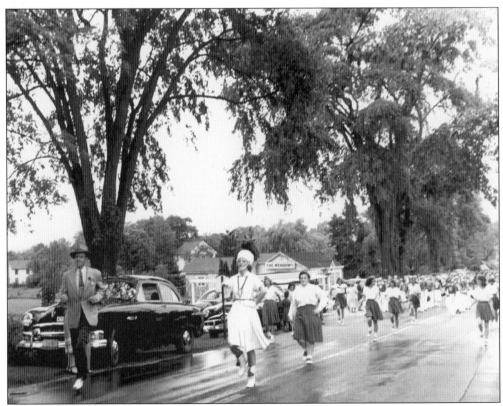

Shown is a Memorial Day parade marching along Underhill Avenue c. the 1950s.

CONTENTS

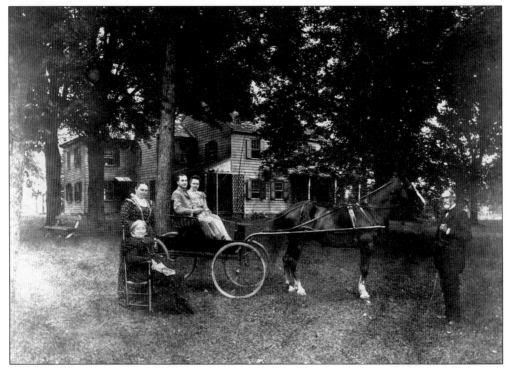

Mekeel, a familiar name in early Yorktown, dates back to the early 1700s. The name was changed to McKeel by a disgruntled family member. The town had a general store named McKeel, and Yorktown has a street named McKeel. Pictured in 1901 in front of the home of Jacob Mekeel are, from left to right, Mary Jane Mekeel, Phebe Anne Mekeel, Miles and Gertrude Mekeel, and Jacob Mekeel Jr.

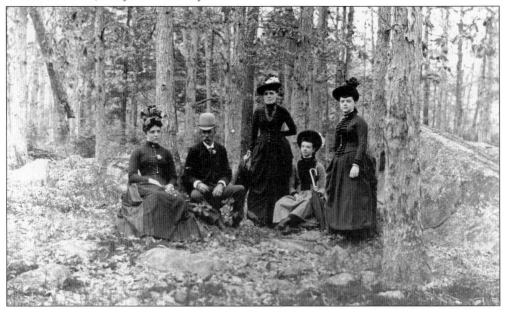

This photograph was taken on May 11, 1889, in Huntersville. From left to right are Ella and Arthur Townsend, Martha Terwilliger, Gertrude Ashcroft, and Maude Bullock.

FOREWORD
What's in a Name?

Most visitors to Yorktown are surprised to discover that the area has known many name changes. The earliest inhabitants were Native Americans of the Algonquin nation who established seasonal encampments throughout northern Westchester. Rivers, lakes, and forests filled with deer and small game provided a productive environment. The Indian name for the area was Keakitis. Ten centuries of Native American settlements were followed by European dispossession. The original immigrants were Dutch. They called the area Crompond, after a small "crooked pond" nearby. The locality later became Van Cortlandt Manor, settled by Stephanus Van Cortlandt, who purchased the land from the natives in 1683. In June 1697, King William III granted the patent for the Manor of Cortlandt. In 1760, the area was named Hanover after the new ruling House of England and, following that, Gertrude's Borough. During the American Revolution, it again became known as Crompond.

However, the origins of the present name go much further back in English history.

When the Danish invaders withdrew from the coastal villages of northeastern England, they left behind the name Yorick for their most important inland North Sea port. It was 200 miles north of London at the confluence of the Ouse and Foss Rivers. The name stuck, and the town prospered.

During the Roman occupation of Britain, Yorick became a strategic hub. By the 15th century, in the intermittent Wars of the Roses, York was grappling with its rival sister city, Lancaster, for the throne of England and soon became one of the century's most important archbishoprics, second only to Canterbury.

In more recent times, the title and emoluments of the Duke of York have been accorded to a British king's younger brother. In 1631, in the New World colony of Virginia, Yorktown, named for the then current duke, was laid out along the banks of the James River. A century and a half later, the sleepy little waterside town would become the renowned battlefield of the American Revolution.

In 1788, to reduce the distance that Westchester farmers had to travel in order to vote against the new U.S. Constitution (because it did not include a Bill of Rights), maverick governor George Clinton and the legislature erected three new townships out of the former Van Cortlandt Manor. One of them, 40 square miles in area, was named York Town after the famous Virginia victory that ended the first U.S. war.

The legislation read: "And that all that part of the said county of Westchester, bounded westerly by the town of Cortlandt, northerly by the county of Duchess, easterly by north lot number 5 and south lot number two of the manor of Cortlandt, southerly by the south bounds of the said manor of Cortlandt, shall be and hereby is erected into a town, by the name of York Town." (From Enrolled Acts of the State Legislature, 1778–1998.)

—Lincoln Diamant

ACKNOWLEDGMENTS

When Linda Cooper and Alice Roker asked me to put together a history of Yorktown, I jumped at the opportunity to tell the story of this Westchester community noted for its rich history and natural beauty. Meeting at the Yorktown Museum every Wednesday was a dedicated and loyal group of volunteers, who included Monica Doherty, Sophie Keyes, and Dolores Pedi, aided by the able museum staff of Adele Hobby, Nancy Augustowski, and Stuart Friedman, the museum board chairman.

I also enlisted the help of former Yorktown resident and American Revolutionary War aficionado John Martino, author of *Yorktown at War*. Otto M. Vondrak brought his expertise and interest in Westchester railroads to the "Old Put" chapter. Lincoln Diamant, noted historian and author of five books on the Hudson River Valley during the American Revolution, gave us his perspective on how Yorktown got its name. Local historian Carl Oeschner contributed his extensive knowledge on the New and Old Croton Dams and the related water system. Croton Heights resident Nancy Truitt chronicled the stories of her neighborhood. Teatown resident Barbara Walker told the story of the many actors who once settled in the area. Former newspaper editor Susan Chitwood lent her background in history to the hamlet chapters. Sophie Keyes collected wonderful stories on some of the historic homes in Teatown and Kitchawan.

Alice Roker collected reminiscences of residents, both past and present. Dolores Pedi gathered many of the images and worked with Linda Kiederer, president of the Yorktown Historical Society, on historical reference material. Unless otherwise noted, all of the photographs came from the Yorktown Archives and Yorktown Museum.

This book would not have been possible without the help of West Moss, a local writer and editor, and Monica Doherty and Adele Hobby, who researched endless details essential to the fabric of this book. A special thank-you goes to all the unidentifiable and identified photographers and volunteers in the Yorktown community who contributed so essentially to the contents of this book.

Finally, a tip of the hat goes to Linda Cooper, who spent long hours going through the Yorktown Archives to find the photographs we used. Her boundless energy, enthusiasm, and love of Yorktown, past and present, lie at the heart of this book.

—Jean Cameron-Smith

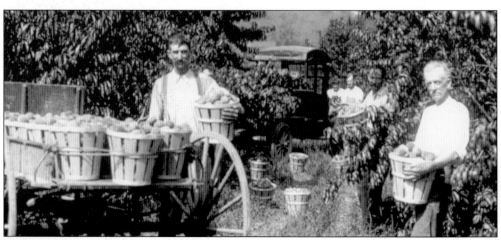

In this 1919 photograph, Apple pickers pause on the Lee Farm, on Route 132.

INTRODUCTION

There is timelessness in the natural world that is not often echoed in our towns and communities. One may revisit a mountain after a 20-year hiatus and find the rocks unchanged. A particular tree may have died, and a new one may be found growing in its place; the path may have shifted to a slightly new position, but the landscape often remains unchanged regardless of the passage of time. A community, however, has an ever-changing landscape affected by the people who move in and out and by the issues of the day.

As we try to capture some of what Yorktown is and has been, a portrait of the community emerges that is a microcosm of the growth of Westchester County and the Hudson Valley, from pastoral hunting and fishing grounds for the Algonquins to an early Dutch settlement as part of Van Cortlandt Manor. We chronicle its growth into a farming community that weathered military campaigns in the War for Independence in the 1700s and during the Civil War in the 1800s. We find a community that changed in the 1800s, when industrialization and the railroad came to the area, and we note that its proximity to New York City led to its becoming a summer haven for many city dwellers in the early 1900s.

As we look back on the 1900s, we see increased development of our neighborhoods and business hamlets. Some can recall the days when Route 202 shut down for 20 minutes each morning and evening to let Farmer Frost's cattle cross from barn to pasture and back again. Some remember the children who rode to school on horseback. There are those who remember when Yorktown had only a few thousand residents, and others who remember the Heights Hamlet before urban renewal began in the 1960s.

The pride and respect that so many feel for Yorktown's history and community is reflected amply in the pages of this book. Yorktown's rich and varied history, coupled with the diverse tapestry of people who have lived here, combine to tell a fascinating story full of drama, history, and inspiration. Needless to say, there are volumes of information that we could not fit between the covers of this book. We invite you to learn more about Yorktown by visiting some of the many remarkable resources in Yorktown, including the Yorktown Museum, the John C. Hart Memorial Library, and the Yorktown Historical Society.

—Linda G. Cooper
Town Supervisor

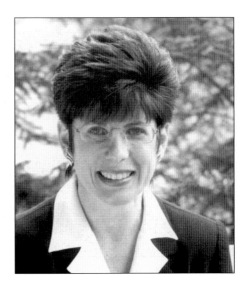

Pictured is Linda Cooper, the town supervisor of Yorktown.

CHRONOLOGY
1683–2003

YORKTOWN
MUSEUM

1683: Stephanus Van Cortlandt buys lands, including Yorktown, from Pewemind and Oskewan sachems.

1697: King William III grants the patent for the Manor of Cortlandt.

1712: Colonial census lists 91 residents of the Manor of Cortlandt (Yorktown).

1730: Lots in the Manor of Cortlandt are divided and sold to settlers from lower Westchester County and Connecticut.

July 18, 1776: George Washington and Alexander Hamilton spend the night at the Delavan house.

October 23, 1776: Revolutionary War entrenchments are constructed on Crow Hill to defend Pines Bridge.

September 2 and 3, 1780: British spy Maj. John André breakfasts at the Underhill house, on Hanover Road.

May 14, 1781: Colonel Delancy's loyalists attack the command post at the Davenport House, killing Col. Christopher Greene, Maj. Ebenezer Flagg, and others.

August 1781 and September 1782: Rochambeau and French regiments establish campsites in Yorktown.

March 7, 1788: The New York legislature changes the town's name from Hanover to York Town.

1788: Town elects Joseph Strang as the first supervisor.

1790: The first census lists 1,609 residents of Yorktown.

1837: The Croton Dam and the Old Croton Aqueduct are begun (completed in 1842).

1881: The railroad comes to Yorktown.

1897: Mohegan Granite Company begins operations.

1898: The Yorktown Grange is established.

1905: Crotonville, Huntersville, and the 1842 dam are inundated by water held by the New Croton Dam.

1908: The St. Nicholas Hotel, in Mohegan, burns.

1909: Yorktown Volunteer Fire Department organizes.

1919: The John C. Hart Memorial Library forms in Shrub Oak.

1922: The Lake Mohegan Fire District is established.

1922: Mohansic Reservation is conveyed to Westchester County for $1, giving Yorktown the first county park.

1923: The first Play Day is held at Mohansic Park.

1923: The Mohegan Colony is established.

1923: A new brick school is built on Commerce Street.

1924: A northward extension of the Bronx River Parkway through the Mohansic Reservation is approved.

1925: The first 18-hole golf course in Westchester is completed at the Mohansic Reservation.

1927: The first full-time police officer is hired.

1933: The Colonial Hotel, in Kitchawan, burns down.

1935: A new wing is added to Yorktown Central School on Commerce Street due to overcrowding.

1935: The Yorktown Town Hall is built.

1938: John Downing begins 25-year service as town supervisor.

1938: Ted Hill begins 22-year service as state assemblyman.

1940: The census lists 3,571 residents in Yorktown.

1955: The first Yorktown master plan is drawn up.

1958: The last passenger train runs on the upper Putnam line.

1960: The census lists 16,453 residents in Yorktown.

1960: A bone from Jefferson's mammoth is unearthed during excavation for the Route 134 parkway exit.

1963: Teatown Lake Reservation is established.

1963: Yorktown Volunteer Ambulance is established.

1965: Yorktown begins operating under Suburban Town Law.

1966: The Yorktown Museum is established.

1966: The Loch Ledge Inn, on Turkey Mountain, burns.

1967: Landmarks Preservation Committee organizes.

1968: The Urban Renewal Agency is created.

1969: The Turkey Mountain Park Preserve is established.

1970: Upper Putnam line discontinues freight service.

1972: The new police building is dedicated.

1973: Town elects first woman, Anne Janak, to board.

1975: Pines Bridge Inn, a local landmark, burns.

1975: Conservation campaign is sparked by multifamily development on Lake Mohegan.

1976: Yorktown Historical Society is established.

1976: Yorktown Bicentennial Committee buries a time capsule at Railroad Park (to be opened on July 4, 2076).

1980: The census lists 31,988 residents in Yorktown.

1980: Town elects first woman supervisor, Nancy Elliott.

1980: Town purchases Commerce Street school for use as Yorktown Community and Cultural Center.

1982: State renames Mohansic Park the Franklin Delano Roosevelt Park.

1983: New master plan is adopted.

1983: The Jefferson Valley Mall is built.

1988: The John C. Hart Memorial Library, in Shrub Oak, is expanded.

1990: The Yorktown Justice Court is built.

1997: The Yorktown Archives and Record Center is built.

1999: Sylvan Glen Park Preserve is created and includes Mohegan Quarry.

2000: The census lists 36,318 residents in Yorktown.

2002: French regimental artifacts are recovered from Rochambeau's 1781 and 1782 campsites.

2002: A building moratorium is declared until a new comprehensive plan for development is completed.

—Monica Doherty

One

DURING THE REVOLUTION

Yorktown, like so many other communities richly steeped in Colonial heritage, seems today so far remote from that uncertain turbulent period known as the American Revolution. Yet between the years of 1775 and 1783, the struggle between Great Britain and the American rebels was to project the ravaging shadow of war across our landscape on a scale never before seen, nor never since known. As in any war, past, present, or future, it is the individuals caught in its web who feel its impact and whose lives are so profoundly scarred in its aftermath. All the manifestations of hate, death, destruction, and pillaging raids were all known and became commonplace to the inhabitants of revolutionary Yorktown. By nature, the American Revolution was a war of divided loyalties that pitted neighbor against neighbor, friend against friend, in a conflict that was to change all of their lives. Some inhabitants joined the ranks of the armies never to return, while others stayed at home to protect their families and properties only to be driven off during or after the war. The geographical proximity of Yorktown to key strategic areas, such as New England, New York City, and the Hudson River, made this town a constant staging ground for both native and foreign armies. Throughout the Revolution, Washington's American army maintained Yorktown as an encampment housing various army elements that guarded the Croton River Crossing. Late in the conflict, the French army under Rochambeau encamped in Yorktown twice, before and after the climatic battle of Yorktown, Virginia. This panorama of armies brought to the town many of the famous individuals who so significantly influenced this critical period. Washington, Hamilton, Rochambeau, and Lafayette, to name but a few, spent some time in our town on more than one occasion.

With a British army firmly established in New York City, rebel supply and communications lines running north to south would be dangerously threatened. Competent British strategy could execute a drive up the Hudson River, isolating New England from communicating with Congress in Philadelphia and further depriving that section of vital raw materials from the middle colonies. It should be noted that the middle colonies of New York, New Jersey, and Pennsylvania were the granaries and chief cattle producers of 18th-century America. Without these commodities, no war could be continued. The campaign for America rested with the control of the Hudson River and its surrounding areas. Certainly Washington, while passing through Crompond on November 11, 1776, grasped this strategic significance of the Croton River and its crossing at Pines Bridge. As long as the Croton River line running from Connecticut to the Hudson River could be maintained, rebel supply and communications could flow through New Jersey, across the Hudson, through Crompond, over Pines Bridge, and then into Mount Kisco, Ridgefield, and New England. Perhaps most appealing to Washington was the fact that the area north of the Croton line, if maintained, could be used as a staging area for a direct assault on New York City by Continental troops.

With the Croton River as the first line of defense against British moves north out of New York City, the town of Yorktown would become the focus of much activity during the critical years of 1779–1781. It was this time period that brought the war to a conclusion, but not without dramatic events for the town, which provided a vital link in the supply and communications chain for the rebel cause. Before this time period ended, town residents witnessed full-scale battle and the arrival of the allies, the French.

Desperately attempting to gain control of the lower Hudson River, the commander of British soldiers in New York, Sir Henry Clinton, in May 1779, launched an offensive of 1,400 men up the Hudson designed to capture Stony and Verplanck's Points. Brilliantly executed, the maneuver sliced rebel communications at Kings Ferry, which ran between the two points, and

placed a large British force well north of the Croton defense line on the east bank of the Hudson. Clinton had stationed nearly 1,000 men at Verplanck's Point, consisting of troops from the 33rd Royal Regiment of Foot, American Volunteers, Beverly Robinson's Loyal Americans, and elements of the 37th Royal Regiment of Foot. The presence of these troops north of the Croton placed Crompond in a precarious position.

On June 3, 1779, the British seized this opportunity to conduct a coordinated raid on the village of Crompond by elements of Beverly Robinson's Loyal Americans, the 37th Regiment of Foot, and Col. Banister Tarleton's British legion. The one bright light for the Americans in 1779 was the brilliant recapture of Stony Point by Brig. Gen. Anthony Wayne on July 16.

Although the evidence is not conclusive, it is apparent that Tarleton's legion, based near White Plains, struck Crompond from the east via Pines Bridge, while a light infantry formation under the command of Lt. Col. Robert Abercromby, based in Verplanck, struck the village from the west on what is now Route 202.

The raid itself was obviously designed to be quick and punitive. No record exists of a large skirmish at Crompond during this raid, indicating that the village was taken by surprise and placed at the mercy of the King's troops. Only the parsonage, then used as a rebel meetinghouse, and possibly one home were put to the British torch. From the British viewpoint, Pines Bridge on the Croton had to be seized and rebel headquarters at Crompond had to be destroyed.

By September 1779, the British, failing to exploit their minor gains on the Hudson, withdrew south to the defenses of Manhattan, relieving pressure on the Croton line. Clinton had received orders to transfer several regiments to the West Indies. Washington, wasting no time in restoring his supply lines over Pines Bridge, ordered Gen. Robert Howe, with the 2nd North Carolina Regiment and the 5th Massachusetts Regiment, to occupy that vicinity on September 13.

To further strengthen the defense of Pines Bridge, Washington on October 18 ordered Gen. Robert Howe to construct gabions and fascines at his posts near the bridge. It is clear that a concerted effort was made to fortify Crow Hill and perhaps even the north side of the bridge. These works on top of Crow Hill are still visible in the form of shallow trenches, which are, in terms of 18th-century warfare, appropriately situated several hundred feet down from the natural hill crest. From Crow Hill, American cannons could command all approach roads to Pines Bridge—a factor never before realized. Accounts of the British raids of June and July indicate that the British had no problem moving on the south side of the river or occupying Crow Hill itself. Apparently, no noteworthy fortifications existed prior to October 1779 atop Crow Hill.

Although the major theater of military operations had shifted to the south, 1779 for Yorktown was a critical year. Full-scale war had finally reached this community in the form of British raids and American encampments. Undoubtedly, these activities served to crystallize the political sentiments of the inhabitants, many of whom greatly resented the destruction of these military maneuvers. Tarleton's raids, for example, probably drove many apathetic civilians to the rebels for protection, while rebel pilfering forced some to the British in New York.

With the war reaching a low ebb for Gen. George Washington in 1780, an allied French army under the command of Gen. Jean Baptiste Rochambeau landed at Newport, Rhode Island, on July 10 of that year. Washington, seeking to capture New York, planned with Rochambeau that both armies would rendezvous north of New York and then assault the city with the French fleet under Admiral DeGrasse in support. For this purpose, Washington in the winter of 1779 ordered missions designed to probe British defenses north of Manhattan.

On May 14, 1781, Col. Christopher Greene, in command of the 1st Rhode Island Regiment, was surprised and killed by Col. James Delancy's loyalist refugees at his headquarters at the Davenport House, overlooking the Croton River on its north bank. Greene had, in mid-April, assumed command of Pines Bridge, with approximately 200 men, most of whom were black

recruits from Rhode Island. These troops were responsible for guarding Pines Bridge and its approaches, extending over a 20-mile area and including Oblenis Ford, one mile west of the bridge.

Today the Davenport House stands on the north side of Croton Heights Road. During the Revolution, the house stood on the south side, but typical of unpaved roads, the road shifted to the opposite side of the house. The remains of Colonel Greene and Major Flagg were interred at the Presbyterian church cemetery in Yorktown, and a mass grave somewhere near the

The members of the Hesse Cassel Jaeger Corps raided Crompond in late June 1779.

Davenport House accommodates the remains of an unknown number of black soldiers from Greene's Rhode Island regiment.

The combined Franco-American army during October 1781, now operating in Virginia, successfully forced a British army under the command of Lord Cornwallis onto a peninsula bounded by the York and James Rivers to the north and south. Confronted by a superior ally to his land side, Cornwallis looked to the British navy to evacuate him from the town of Yorktown, Virginia, into which he had withdrawn. The French fleet was able to repel a British rescue effort moving toward Chesapeake Bay and, consequently, Cornwallis was trapped. American and French troops, characterized by splendid cooperation, slowly ground down the British force, which surrendered on October 19, following a 20-day siege. The Cornwallis disaster convinced the British that the war could not be won, and for the most part, hostilities ceased to exist after October 1781.

Following the winter of 1781–1782, Washington and Rochambeau moved their forces slowly northward, reaching the east bank of the Hudson River in late September 1782. After a brief encampment, with the American army in Peekskill, Rochambeau's army of 5,388 men on September 24 marched east to Crompond and encamped in the vicinity of Hunt's Tavern, to act as the eastern vanguard for the American army at Verplanck's Point.

The French army encamped in Yorktown from September 24 to October 22, 1782. While stationed in town, they occupied the area near the intersection of Hallock's Mill Road and 202. Two regiments encamped on the high ground directly behind Freyer's Nursery, overlooking Brookside School to the east and 202 to the west. Another regiment encamped on the northern slope of French Hill, facing Little Mohansic Lake. Another unit encamped along the north side of Baldwin Road, as during the first French encampment, in August 1781. This area of town was selected for its proximity to the water supply of Mohansic Lake and for its high ground, which was suitable for military purposes.

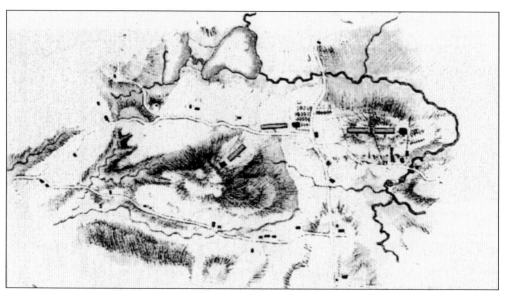

This was the Crompond encampment of the French, occupied from September 16 to October 22, 1782. Visible is the deployment of regiments on French Hill (south of Baldwin Road) and northeast of Freyer's Nursery. Notice the location of homes and the flow of the stream moving east from Little Mohansic. This stream became the subject of controversy upon the departure of the French army on October 22, 1782. The flow of the stream was diverted from its original direction after the French army dug canals in return for firewood and camping rights. The Lanzun Legion camped to the south near the Hanover Farm in 1781 and 1782.

As winter approached, camp life at Crompond was not particularly exciting for the French troops. "We arrived at Crompond where we stayed for a month. This place is a wilderness where we had no recreations save fishing, since hunting was forbidden because of the Refugees (Loyalists) bands in the neighborhood. We captured three who were plotting to kidnap some of our army. Oct., as the weather grew perceptibly colder our regiment built barracks for itself. . . ."

Clermont Crevecoeur, a lieutenant of the Auxonne Artillery Regiment, mentions that they drew water from a neighboring pond (Crompond), "where the water was not good." He also mentions the construction of barracks by his regiments. Although these structures are no longer in existence, Thomas Sharf in 1886 states that "ovens constructed by the French for baking bread are still to be seen on the Flewellen Farm (behind Freyer's) and a number of military buttons have been found there." Sharf further relates an incident involving Isaac Underhill, a local farmer making claim to General Rochambeau that a French soldier, without permission, stole some potatoes from his field. Rochambeau, determined to maintain discipline, had the soldier put to death, despite Underhill's objection.

As the entire French army prepared to depart from the Crompond camp on October 22, one of the most bizarre incidents of the Revolution occurred. The incident involved the claims of Crompond resident Samuel Delavan, who had hosted Rochambeau at his home and whose property part of the French army had camped upon, complained to the local sheriff that Rochambeau did not compensate him for the wood that was consumed by the French troops. The sheriff, responding to Delavan's complaint, halted Rochambeau at the head of his columns to serve him with an order of arrest. To the French, this was truly noteworthy, and several contemporary accounts exist detailing the confrontation between the general and the sheriff. Rochambeau, in his memoirs, viewed the whole affair as somewhat amusing, while his son, Viconte de Rochambeau, a lieutenant colonel in the Bourbonnais Regiment, thought Delavan to be a scoundrel for making such a claim.

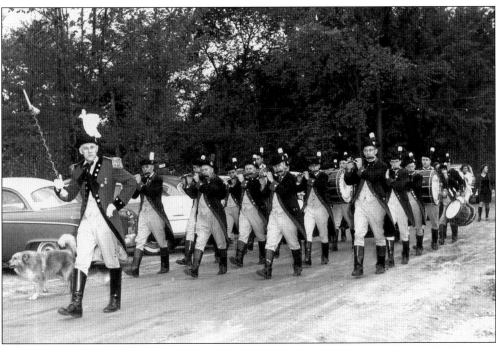

Shown is a reenactment of General Rochambeau's march through Yorktown, held at the dedication of the Grange grounds of Rochambeau Park in 1958.

Delavan, similar to so many other Americans of that period, was attempting to profit from the healthy treasury of the French army. In addition, Yorktown residents may want to pay close attention to the stream that runs from Lake Mohansic under Route 202 (south of the police station) and around Freyer's Nursery. The French army widened the stream in order to improve the granary mill situated one and a half miles from Mohansic Lake. It was this stream that was at the center of the controversy between the sheriff and the general. Fortunately for them both, Rochambeau met the situation with benevolence and understanding. The handling of this affair may have saved Rochambeau from the guillotine years later. The event became part of a character reference in his trial by revolutionaries who let him go at the outset of the French Revolution.

The exit of the Rochambeau army marked the end of the Revolution for Yorktown. To be sure, some American troops remained in the area until the final peace settlement in 1783, while the British remained in New York City. Yet even these victorious rebel troops were tired of war, and many just simply left for home without being discharged.

Eight years of war was enough for anyone. For the residents of Van Cortlandt Manor and Crompond, the war had been ravaging. "Their homes were desolated, their furniture broken to pieces, their cattle and horses were gone and their orchards and fences burned, their fields covered with weeds and wild grass, and the highways and roads destroyed." Many residents never returned to the homes known to them prior to the war; since they were Tories, they were not welcome back. As with the rest of the nation, the war had changed Yorktown forever. Those who remained had the difficult task of piecing together a life that had been irreparably torn apart by war.

—John Martino
Adapted from his book *Yorktown at War*

The André-Underhill House was built in 1756 by Isaac Underhill. It is locally famous because, on September 23, 1780, the last day of his freedom, British spy Maj. John André stopped here for breakfast. In his boot he was carrying the West Point plans that Benedict Arnold gave him. André was captured in Tarrytown.

Two

THE CIVIL WAR YEARS

Although slavery was abolished in New York State in 1827, the assisting of a runaway slave was a violation of the Fugitive Slave Act, passed by Congress in 1850. This law allowed that any runaway slaves, regardless of how long they had been free or where they were living, had to be apprehended and returned to their owner. Abolitionists in the Northern states were instrumental in helping fugitive slaves find their freedom. There was great danger inherent in protecting freed slaves. Since large monetary rewards were offered for their capture and return, avaricious bounty hunters roamed the roads and streets, seeking runaway slaves for profit. The Underground Railroad, which was organized and started prior to the Civil War, came into full form during the war. It was a route that enabled some 50,000 slaves to escape slavery in the Southern states and find refuge in the Northern states and Canada.

The name of the Underground Railroad was due to the popularity of railroad terminology in the American vernacular of the era. Railroad terms are sprinkled throughout the language of the movement. For instance, citizens who helped the slaves move from place to place were called "conductors." The secluded havens where the slaves were given shelter were called "stations." The slaves were sometimes referred to as "packages" or "freight" and were taken into the Northern states by different routes or "lines."

Harriet Tubman, a former slave herself, is considered to be one of the most famous "conductors" and is credited with helping more than 300 slaves to freedom. On January 31, 1865, Congress approved the 13th Amendment to the Constitution, outlawing slavery in the United States.

Due to the extreme danger and secrecy of helping escaped slaves move through Westchester, written records were seldom kept. Thus, little is known of how many citizens in Yorktown were "conductors" and provided safe "stations." In 1978, Alice Bushnell Noble, a Yorktown resident, described a safe haven used to shelter runaway slaves in a pre–Revolutionary War house she had lived in, known as the Davenport House. The house is a historic landmark and is one of the few Revolutionary War command posts still standing in Westchester County.

The American Civil War (1861–1865) was a conflict between the Northern Union army and the Southern Confederacy. Abraham Lincoln was elected the 16th president of the United States in 1860. He argued for compensated emancipation for all slaves. At that time, 15 of the 31 states were slave states, and the country was divided by the issue of slavery and thrown into political turmoil. Southerners were angered that their ways of life and commerce were being challenged, and they voted to secede from the Union. Thus, the American Civil War began, as the North fought to bring the Southern states back into the Union.

During the Civil War, the town of Yorktown responded promptly to Lincoln's call for troops. Yorktown was one of the few towns that reimbursed all individual expenses to those residents who were unable to secure a substitute to fight in their stead. By 1862, it had become necessary to pay bounties to get volunteers. The sum of $5,000 was raised by tax on the town and used in the payment of bounties, which ranged from $40 to $110 (plus incidental expenses).

A resolution adopted in 1863 in Yorktown established a system of mutual insurance against draft for its citizens. It provided that every person eligible for military service who paid $30 into a common fund would be entitled, if drafted, to $300 from the town. This money was to be used either to obtain a substitute or to pay the government for the draftee's exemption. A copy of the handbill, dated October 6, 1863, announced that a meeting would be held "To Create a Fund to Aid drafted persons from Yorktown." In 1864, taxation on town property and issuance of bonds funded the reimbursement for substitutes. In addition, a sum of $49 was raised, to

reimburse those who had contributed to the mutual insurance fund against a draft.

On December 18, 1864, a last call was made for volunteers. Residents who received a notice of enrollment and secured a substitute were issued a certificate of non-liability by the Board of Enrollment. Some 281 men from Yorktown (mostly farmers, farmhands, and carpenters) enlisted between 1861 and 1864. The population of Yorktown in 1860 was 2,231. During this same period, the number of men from Yorktown who fell in battle or died in military service was listed as 19. They were buried in local cemeteries.

Records indicate that during the Civil War, there was a large house and barn on the property where Downing Park now stands, on Crompond Road. Guns and supplies were stored in the barn, and the open area was used as a drill ground for local Civil War recruits.

There were 11 school districts in Yorktown at the time, each with one teacher. One-room and two-room schoolhouses were commonplace. Schools were spaced roughly three miles apart.

Part of the local lore of the time included a mysterious man known as the Leather Man. Referred to as "the strangest specimen of Man," he remains largely a mystery. He did not speak and was clad from head to toe in a suit of leather. He regularly traveled a 300-mile circuit every 34 days. His route took in Yorktown, Bedford Hills, Ossining, White Plains, Brewster, Peekskill and other towns. He carried his belongings in a leather bag including cooking utensils, a small axe, and tools to repair his leather garments. He slept in caves and barns, one of which was on a hillside in Yorktown's Turkey Mountain Park (still a popular spot for hikers). He also regularly bunked at an inn on the original Albany Post Road that is now known as Sundial Farm. In 1889, the Leather Man was found dead in a cave in Ossining and was buried in the local Sparta Cemetery.

—Monica Doherty

COMPLETE RECORD,

AS REQUIRED BY CHAPTER 690, OF THE LAWS OF 1865,

RELATING TO

OFFICERS, SOLDIERS AND SEAMEN,

COMPOSING THE QUOTAS OF THE TROOPS FURNISHED

TO THE

UNITED STATES,

BY THE

Town of Yorktown

County of Westchester

STATE OF NEW YORK,

In the war of the Rebellion, and covering the period from the 15th day of April, 1861, to the date of the Certificate of the Town Clerk, attached to this Record.

PREPARED BY

Martin Van-Buren Travis

Town Clerk.

NOTE.—After completing this Record, and before returning it to the Bureau of Military Record, the Town Clerk will please make the Certificate, for which a blank form is printed on the page next after the Naval Record, in this book.

The muster record for Yorktown's Civil War soldiers was prepared and signed by Town Clerk Martin Van-Buren Travis.

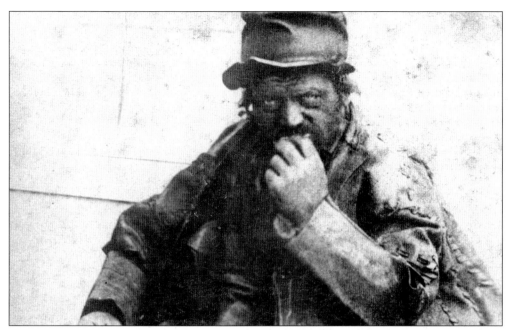

In the late 1860s, a man of myth and mystery appeared. This solitary, non-verbal bearded individual was called the Leather Man. Dressed in a suit of leather from head to toe, this silent wanderer was a familiar sight as he traveled a 300-mile circuit through Yorktown, Bedford Hills, Ossining, White Plains, Norwalk, Saybrook, Danbury, Brewster, and Peekskill in 34 days.

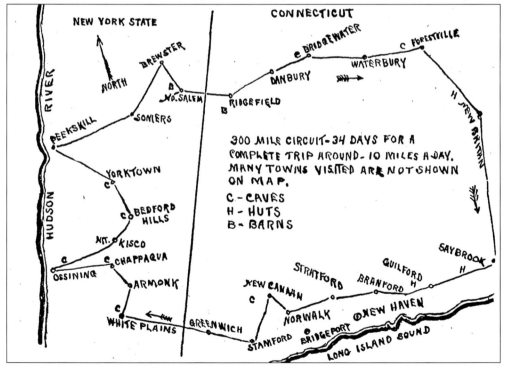

This hand-drawn map indicates the 300-mile route the Leather Man traveled. It is estimated that it took him 34 days, averaging 10 miles a day, to complete this circuit.

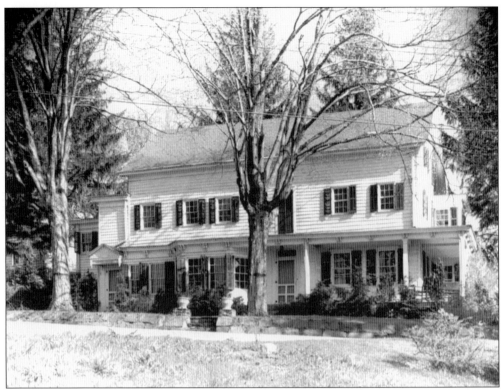

The Davenport House, built in 1750, was best known as the Northern headquarters for Gen. George Washington's troops throughout the American Revolution. However, it was also believed to be a safe house in the Underground Railroad, used to shelter runaway slaves.

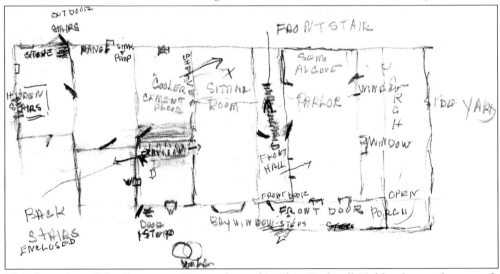

This floor plan of the Davenport House, drawn by Alice Bushnell Noble, shows where a safe and secret haven existed that was used to shelter runaway slaves during the Civil War. The house is a historic landmark and is one of the few Revolutionary War command posts still standing in Westchester County. Due to renovations in later years, the hidden staircase no longer exists.

Record of Manumission of Yorktown

"By a certain act of legislature passed the 22nd day of February 1788, it is the duty of the overseers of the poor and 2 justices of the peace in any town in this state to sign a certificate to any person who shall be disposed to manumit his slave."

1. Richard Hallock manumits his slave, a man of under 50 years. 8/14/1794

2. Stephen Lines manumits his manslave, Benjamin, who is under 50 years. 12/13/1798

3. Stephen Horton - his slave Peter (under 50) 10/3/1798

4. Reubin Garrison-his negro slave-woman 10/20/1798

5. Ebenezer White-his slave Dick 11/27/1800

6. Richardson Davenport manumits his slave Exe 12/6/1800

7. Richard son Davenport manumits his slave James (60 years old) 12/26/1800

8. John Hyatt manumits his slave Soloman (about 27 years) 5/20/1801

9. Ebenezer White manumits his slave Primasani (under 50 years) 12/21/1805

10. Abren Purdy manumits his slave Sinah 9/5/1806

11. Robert Flewwellen manumits his slave Jack 5/19/1817

Record of negro children born of slaves in the Town of Yorktown after the 11th day of July in the year 1799

7/25/1802 George Titus certifies that a girl, Peggy, was born to his "negro woman" on this date

10/26/1803 Susan Delancy certifies that her "negro woman Hannah" bore a child named "Harreat"

6/24/1803 Gabriel Knapp, farmer, certifies that his negro woman bore a "negro child named Nana"

12/22/1804 Caleb Morgan certifies that his negro woman bore a child named Brister

7/23/1806 Elijah Lee certifies that his "negro woman Hannah, a slave," bore a child named Ben

6/23/1809 Ebenezer White certifies that his negro woman bore a male child

The oldest vital record in the town, the *Book of Manumissions*, was found by Town Clerk Alice Roker in a metal cabinet in her office. Labeled Book 9, 1782, it was written in three parts. The first part deals with stray animals. The second part is a record of the children born to slaves. The third part details those slaves who were manumitted, or freed, by their owners.

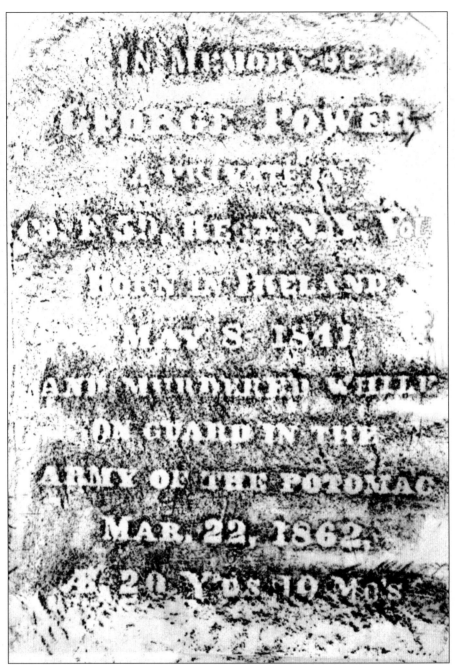

IN MEMORY OF
GEORGE POWER
A PRIVATE IN
CO K 63 REGT N.Y. VOL
BORN IN IRELAND
MAY 8, 1841
AND MURDERED WHILE
ON GUARD IN THE
ARMY OF THE POTOMAC
MAR. 22, 1862
AGED 20 YRS 10 MOS

This tombstone at the First Presbyterian Church of Yorktown marks the grave of Pvt. George Powers, who died on March 22, 1862. He was murdered while guarding a lock on the Ohio and Chesapeake Canal near the Chain Bridge in Maryland. He was only 20. His body, along with his military gear, was found when the canal was drained. The mystery remains concerning why he was buried in Yorktown. It was common practice that soldiers killed in the line of duty were brought home by their respective families, but Powers had no family members on record in Yorktown, his only local connections being a job he held at Fowler farm prior to his enlistment and a friendship with resident Hanna Reynolds.

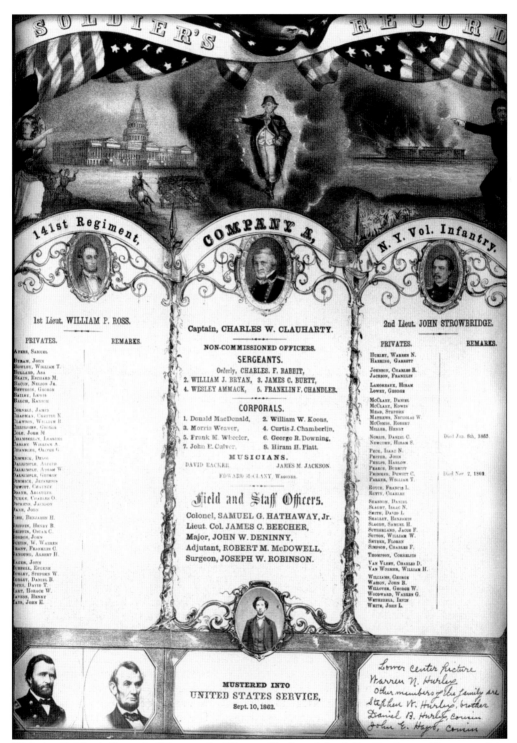

SOLDIER'S RECORD

141st Regiment, COMPANY A, N. Y. Vol. Infantry.

1st Lieut. WILLIAM P. ROSS.

Captain, CHARLES W. CLAUHARTY.

2nd Lieut. JOHN STROWBRIDGE.

PRIVATES.	REMARKS.
AYERS, SAMUEL	
BYRAM, JOHN	
BOWLEY, WILLIAM T.	
BULLARD, ASA	
BLAIN, RICHARD M.	
BACON, NELSON JR.	
BETTERSON, GEORGE	
BAILEY, LEWIS	
BALCH, RANSOM	
CORNELL, JAMES	
CHAPMAN, CHESTER K	
CLAWSON, WILLIAM B	
CHISSOMS, GEORGE	
COLE, JOHN M	
CHAMBERLYN, LEANDER	
CARLEY, WILLIAM A	
CHANDLER, OLIVER G	
DIMMICK, DENNIS	
DALRIMPLE, ALFRED	
DALRIMPLE, ADAM W	
DALRIMPLE, GEORGE	
DIMMICK, JEFFERSON	
DEWITT, CHAUNCY	
DOANE, ABIATHER	
DURKE, CHARLES O	
DICKENS, JACKSON	
FANE, JOHN	
FISH, BENJAMIN H.	
GRIFFIN, HENRY B.	
GRIFFIN, ORCAS C.	
GORDON, JOHN	
GUSTIN, W. WARREN	
GRANT, FRANKLIN C.	
HANDUNG, ALBERT B.	
HAGER, JOHN	
HURBELL, EUGENE	
HURLEY, STEPHEN W.	
HOBART, DANIEL B.	
HICKS, DAVID T.	
HART, HORACE W.	
HAVENS, HENRY	
HAYS, JOHN E.	

NON-COMMISSIONED OFFICERS.

SERGEANTS.

Orderly, CHARLES. F. BABEIT,
2. WILLIAM J. BRYAN, 3. JAMES C. BURTT,
4. WESLEY AMMACK, 5. FRANKLIN F. CHANDLER.

CORPORALS.

1. Donald MacDonald, 2. William W. Koons,
3. Morris Weaver, 4. Curtis J. Chamberlin,
5. Frank M. Wheeler, 6. George R. Downing,
7. John E. Culver, 8. Hiram H. Platt.

MUSICIANS.

DAVID EACKER JAMES M. JACKSON

EDWARD McCLANY, WAGONER.

Field and Staff Officers.

Colonel, SAMUEL G. HATHAWAY, Jr.
Lieut. Col. JAMES C. BEECHER,
Major, JOHN W. DENINNY,
Adjutant, ROBERT M. McDOWELL,
Surgeon, JOSEPH W. ROBINSON.

PRIVATES.	REMARKS.
HURLEY, WARREN N.	
HARRING, GARRETT	
JOHNSON, CHARLES R.	
JACKSON, FRANKLIN	
LAMOREAUX, HIRAM	
LOWRY, GEORGE	
McCLARY, DANIEL	
McCLARY, EDWIN	
MEAD, STEPHEN	
MATHEWS, NICHOLAS W.	
McCOMBS, ROBERT	
MILLER, HENRY	
NORRIS, DANIEL C.	Died Jan. 6th, 1863
NEWCOMB, HIRAM S.	
PECK, ISAAC N.	
PEPPER, JOHN	
PHELPS, HARLOW	
PEARCE, BURRITT	
PRIDMORE, DEWITT C.	Died Nov. 2, 1862
PARKER, WILLIAM T.	
ROYCE, FRANCIS L.	
RUTTY, CHARLES	
SHANNON, DANIEL	
SLAGHT, ISAAC N.	
SMITH, DAVID L.	
SMALLEY, BENJAMIN	
SLAGHT, SAMUEL H.	
SUTHERLAND, JACOB F.	
SUTTON, WILLIAM W.	
SNYDER, FLOREN	
SIMPSON, CHARLES F.	
THOMPSON, CORNELIUS	
VAN VLEET, CHARLES D.	
VAN WORMER, WILLIAM H.	
WILLIAMS, GEORGE	
WARON, JOHN B.	
WILLOVER, GEORGE W.	
WOODWARD, WARREN G.	
WETHERELL, IRVIN	
WHITE, JOHN L.	

MUSTERED INTO UNITED STATES SERVICE,
Sept. 10, 1862.

Lower center picture
Warren N. Hurley
Other members of the family are
Stephen W. Hurley, brother
Daniel B. Hurley, cousin
John E. Hays, cousin

This is a Soldier's Record of Service for Warren Hurley of the 141st Regiment Company A in the New York Volunteer Infantry. Members of this unit could purchase a record like this one and personalize it with their photograph.

SPECIAL
TOWN MEETING!

To RANDOLPH M. LEE, Esq.,
Town Clerk of the town of Yorktown,
in the County of Westchester :

We, the undersigned, inhabitants and freeholders of said town of Yorktown, eligible to the office of Supervisor of said town of Yorktown, do make application to you to call a Special Town Meeting as soon as the requirements of the law will permit, for the purpose of voting upon such measures as may be submitted to them at such Special Town Meeting, to raise money by tax, or upon the credit of said town, to be used in procuring substitutes for such persons as may be drafted in said town of Yorktown under an Act of the last Congress commonly known as the Conscription Act ; and to be used otherwise, if necessary, to relieve such persons from such draft, or in aid of them and their families.

Dated Yorktown, September 14, 1863.

Robert Knapp,
John Hyatt,
W. H. Birdsall,
Robert Vredenburgh,

Elias W. Travis,
Elias Q. Tompkins,
Henry White.
Benjamin Curry,
James Travis.

Alson Secor,
Jerome Wildy,
Henry Dillingham,
Wm. Hart Purdy,

In accordance with the petition of the
above named citizens of the town of Yorktown, a SPECIAL TOWN MEETING will be held at the house of MATTHEW BOYCE, in said town, on

WEDNESDAY, SEPT. 23D,
AT TWO O'CLOCK, P. M.,

For the purposes set forth in the above petition.
Dated September 15th, 1863.

RANDOLPH M. LEE, Town Clerk.

Highland Democrat Print, Division St., Peekskill.

This notice announces a special town meeting to raise money by taxation to procure substitutes or to aid the families of soldiers going to war.

24

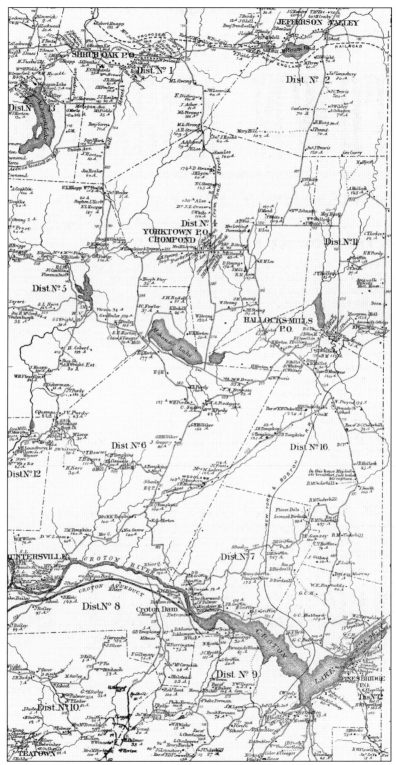

A map drawn in 1872 shows the town of Yorktown as it was shortly after the Civil War.

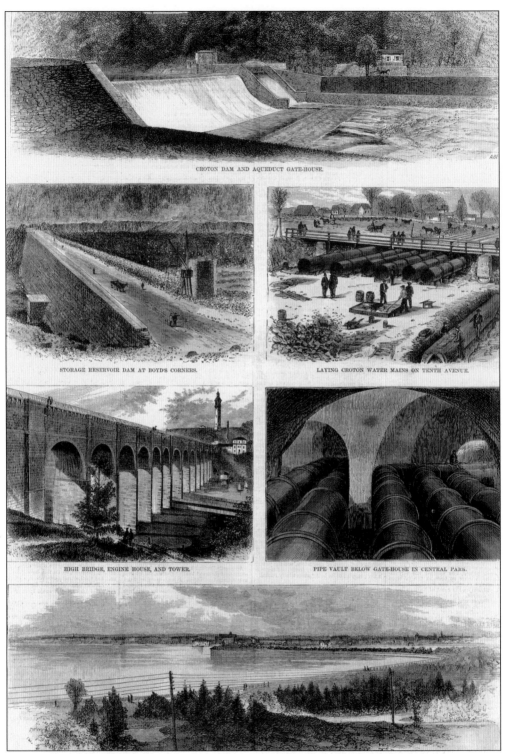

CROTON DAM AND AQUEDUCT GATE-HOUSE.

STORAGE RESERVOIR DAM AT BOYD'S CORNERS.

LAYING CROTON WATER MAINS ON TENTH AVENUE.

HIGH BRIDGE, ENGINE HOUSE, AND TOWER.

PIPE VAULT BELOW GATE-HOUSE IN CENTRAL PARK.

The January 25, 1873 edition of *Harper's Weekly* shows the routing of New York City water supply from Yorktown to Central Park via the Old Croton Aqueduct.

Three
WATER FOR NEW YORK

During the Colonial period, the city of New York did little to ensure an adequate and safe supply of water for the citizens of its growing community. A series of government efforts to create municipal water companies met with disorganization and corruption.

Two devastating events finally motivated the city to create a plan to supply clean water for its citizens. The first was the cholera epidemic of 1832, in which 2,000 people died. The toll would have been higher, but some 150,000 residents fled, leaving an "unwanted silence" pervading the city. One could walk the length of Broadway and "scarce meet a soul." The second disaster that urged the city to secure an ample water supply was the Great Fire of 1834 that consumed an estimated 700 buildings. A newspaper reported, "The morning of the 17th of December opened upon New York with a scene of devastation sufficient to dismay the stoutest heart." The city's chief disadvantage against the fire's onslaught was the lack of water. New York still took most of its drinking water from neighborhood wells, which had grown increasingly polluted. Spring water, carted from up island, supplied only those who could afford it. The time had come for a better system.

A number of suggestions had been made to solve the problem. In 1789, Dr. Joseph Browne designed a dam and canal system across the Bronx River into the Harlem River with a waterwheel filling a reservoir on Manhattan. In 1819, Robert Macomb proposed to bring water from Rye Pond to a reservoir on the Harlem River before distributing it to the city. In 1830, John L. Sullivan suggested building a navigable canal from the Passaic River for both water and commerce to flow between Pennsylvania and New York. Finally, in 1834, Bradford Seymour proposed building a dam across the Hudson River from New Jersey to New York. The dam would prevent saltwater encroachment, and locks would allow navigation on the river, while river water would be pumped to a reservoir for city consumption.

The year 1835 saw a population of 350,000 in New York City. Each citizen was using an average of 26 gallons of water a day, and it was clearly time for a plan. In 1835, city voters approved the building of a 42-mile aqueduct, dam, and reservoir that would carry fresh water from the Croton River in Yorktown into Manhattan. Maj. David B. Douglass, West Point professor, was appointed chief engineer for the project. He and his assistants laid out the line of the 42-mile brick conduit, as well as the spot for the new dam and "lake" (reservoir). For political reasons, John Bloomfield Jervis, who had worked on both the Erie Canal and the Delaware & Hudson Canal, replaced Douglas in 1836.

Work on the dam began in 1837. By then, the city had already moved houses, barns, outbuildings, mills, roads, and bridges to make way for the new public works project. Jervis decided to build the Yorktown Dam across the narrowest span of the Croton River (120 feet) where bedrock ran under the river. Unfortunately, the bedrock ran only partially across the stream, with much of the remainder being made up of gravel and sand. The design called for a 50-foot-high masonry dam with a spillway 100 feet long and an added earthen embankment 55 feet across at the top. A 400-acre reservoir would raise the level of the river by 40 feet and deliver 72 million gallons of water per day.

From 1837 to 1847, Jervis dealt with many issues that complicated the massive project. He had to obtain large amounts of granite and sand, as well as deal with dishonest contractors who "absconded with money leaving laborers unpaid." Letters appeared in city newspapers from people as renowned as local author Washington Irving, who strove to create worker unrest. Not wanting construction so close to his property, Irving did his best to offend the largely Irish workforce by writing letters full of stereotypical jokes. Yorktown residents who went to court to

halt the project included the nearby powerful Van Cortlandt family. A worker strike in 1838 demanded higher wages and threatened to derail the project.

The single event that most challenged Jervis took place in January 1840, when fine fall weather gave way to wintry conditions in Westchester. A series of heavy snowfalls was coupled with record low temperatures well into January. Temperatures were below zero on January 8, when, just after midnight, the rising Croton River wrenched Pines Bridge from its footing and sent it rushing toward the unfinished dam below. At 2:00 in the morning, the earthen section of the structure collapsed, carrying debris 16 miles downriver, where it was destroyed. The only structure remaining in the river was the masonry portion of the dam. Three people lost their lives in the flood, with damage ultimately amounting to $700,000. The burst dam ended real navigation on the Croton River.

Jervis quickly rebuilt the structure and finished the 42-mile aqueduct into New York City, ending at a receiving reservoir in Central Park and finishing at the distribution reservoir on Fifth Avenue and 42nd Street, now the site of the New York City Public Library. The project was finally completed and opened in June 1842. Jervis commented on the new Yorktown Dam and Reservoir: "The countryside immediately contiguous to the shore of the lake has been cleared up, and all what would be liable to impact any impurity to the Croton water has been removed. This gives a most pleasing aspect to the lake showing where the hand of art has swept along the shores leaving a clean margin. There are walks around the new dam with grassy areas that give it a neatness and finished appearance. It is my thought that this region would indeed be a most pleasurable resort location for the citizens of our noble city."

The Old Croton Dam, now a National Historic Landmark, was the first large masonry dam built in the United States and was the prototype for numerous municipal water supply dams built in the East during the 19th century. In 1973, it was listed on the National Register of Historic Places as an underwater archaeological site.

—Carl Oechsner and Linda Cooper

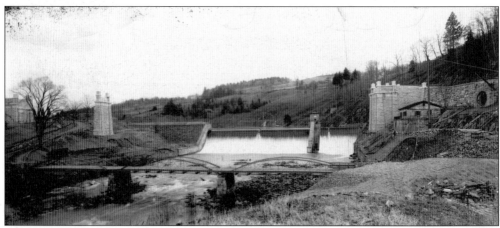

Taken in the spring of 1904, this photograph shows the old Croton Dam, completed in 1842, allowing a fresh, clean water supply to reach New York City via a gravity-fed system. Today, the old dam is a National Historic Landmark.

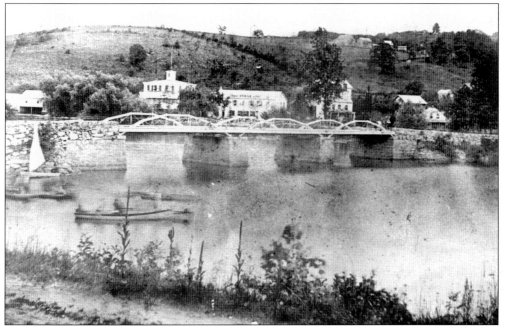

Shown is the Old Pines Bridge spanning the reservoir. In the background are the hotels located at the base of Crow Hill Road. Some of these hotels burned down in later years. This photograph was taken prior to 1895.

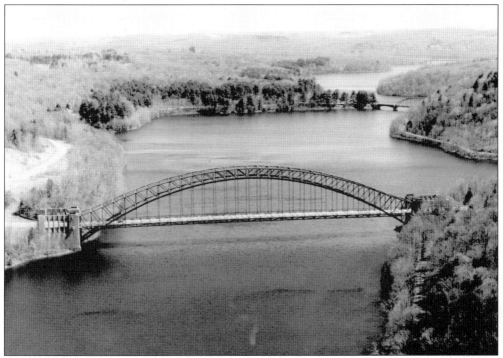

This view of the reservoir shows the northbound Taconic Parkway Bridge, the Gatehouse Bridge, and the North County Trailway Bridge, formerly the Old Put Bridge. The photograph was taken in 1986 by Fred Marsh.

A 1904 photograph shows two of the known four Pines Bridges that have existed since before the American Revolution, when a ferry operated across the Croton River. Before the valley was flooded for the new Croton Dam, the buildings in the foreground were relocated to higher ground and combined to become the Pines Bridge Inn.

The Taconic Parkway Bridge across the reservoir was under construction when this photograph was taken from the north side of the reservoir on October 1, 1931.

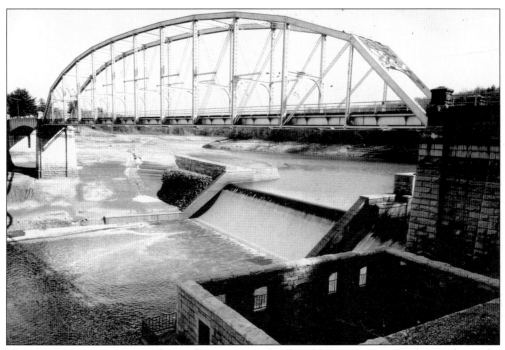

This 1949 photograph was taken at low water under the old Croton Dam Bridge. It shows the old Croton Dam and gatehouse, both of which were flooded over by new reservoir.

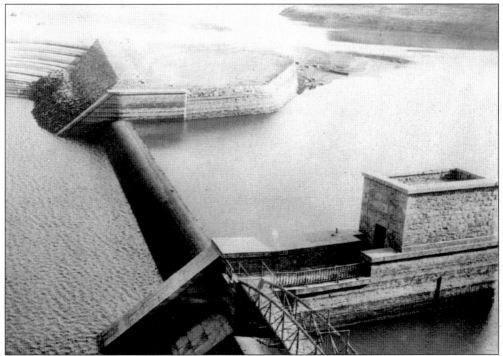

Low water levels reveal the outline of the old Croton Dam in this photograph taken on November 17, 1949. The old Croton Dam ceased to be the primary impoundment for New York City's water supply when replaced by the new Croton Dam in 1907.

IMPORTANT
Time shown herein is Daylight Saving Time
EFFECTIVE APRIL 29, 1956

NEW YORK CENTRAL

PUTNAM DIVISION

SUBURBAN

TIME TABLE

- Sedgwick Avenue
- Bryn Mawr Park
- Nepperhan
- Ardsley
- Elmsford
- Briarcliff Manor
- Yorktown Heights
- Lake Mahopac
- Brewster

**and Intermediate Stations
also Connecting Train Service to and
from Grand Central Terminal**

Form 114

Shown is a passenger timetable for the New York Central Putnam Division, dated April 29, 1956. Passenger service on "the Put" lasted only two more years. In order to reach Grand Central Station, passengers had to make a connection to a Hudson Division train at High Bridge in the Bronx.

Four
THE OLD PUT

Local residents and rail buffs speak nostalgically about "the Old Put," which once ran through town. The railroad ran for almost 90 years in Yorktown and served well, despite its false starts early on.

The railroads of the East were pretty well developed by the outbreak of the Civil War. It seemed that Westchester County was already enjoying adequate service to New York City from the New York & Harlem Railroad and the Hudson River Railroad. Although 1869 seems like a late entry into the railroad business, the early organizers of the New York, Boston & Montreal Railroad thought otherwise. Their planned route would run from a terminal in New York, up through Putnam Valley to Brewster, and then make connections to Boston and Montreal, respectively.

The New York, Boston & Montreal Railroad was a far-flung empire that made sense on paper only. The Panic of 1873 put any grand plans on hold. In 1879, the New York, Westchester & Putnam was formed to hold any assets of value, namely the unfinished railroad running from High Bridge in the Bronx all the way up to Carmel. The New York City & Northern Railroad was formed in 1878 to complete the railroad project.

At the time, Crompond Corners was a small community consisting mainly of a Presbyterian church, cobbler's shop, slaughterhouse, tannery, tavern and inn, and post office. Most of the town was centered on what is today the intersection of Routes 202 and 132. The arrival of the railroad spurred the growth of the area. In 1870, land was purchased from Edward B. Underhill and Silas C. Whitney for railroad construction. The hamlet of Underhill rapidly developed around the tracks after regular service began in 1877. Aaron Clark opened the first shop south of the depot on August 27, 1877. By then, the town consisted of five stores, more than a dozen homes, a schoolhouse, a hotel, two blacksmiths, a wheelwright, and two churches. This growth continued through the 1880s.

Regularly scheduled service commenced in 1880. The railroad changed its name to New York & Northern on October 11, 1887. With frequent and reliable service to New York City, it was now possible for farmers to inexpensively transport large quantities of their milk and produce to the markets in New York. The railroad was primarily responsible for the development of Yorktown as an agricultural breadbasket of Westchester County through the end of the 19th century.

The railroad remained a marginal success through the 1880s as a link for freight and passengers coming from New England, making connections at Brewster. It was realized that the New York & Northern would not become an alternate link to New York, and on-line traffic was not developing as hoped. The New York Central took over the line in 1896 to keep it out of any future competitor's hands. The New York Central officially named the line the Putnam Division, but locals endearingly referred to it as the Put.

In 1902, land was acquired in Yorktown from Henry C. Kear for the construction of a storage yard and light-engine servicing facilities. The yard was used to store passenger trains and to clean them between runs. Today, the town highway department occupies the site. Also in 1902, a spur was planned and constructed to serve the newly formed New York State training school for boys, located at the south end of the lake. The Mohansic Spur branched off from the main one at the Yorktown depot, curving northwest through town before heading west and terminating alongside the main administration building for the school.

In 1911, plans were drawn to establish an insane asylum along the lake. Preliminary work had begun when problems arose. Some inmates had been transported to the site before any

structures were built. They had managed to kill the guard assigned to watch over them. Support for the plan quickly waned. In 1915, the city of New York blocked construction, since the projected structures would put too much strain on the watershed area surrounding the reservoir, possibly contaminating the water supply. With weight restrictions on the wooden trestle crossing the marsh and no hope for future traffic, the entire branch was abandoned in 1917. Today, it is being turned into part of the Yorktown Trailway Network that will connect to the North County Trailway.

Kitchawan station was a one-story frame structure located along the southern shore of Croton Lake, off Kitchawan Road just west of Route 100. It contained a waiting room, a ticket office, and a baggage room. It was larger than the station in Yorktown, although it served a less populated area. Boarded up since the end of passenger service in 1958, the building burned down on September 16, 1960.

The stop at Croton Heights, off Route 118, was little more than a flag stop with a simple structure of three walls and no agent. The customers who used the station were very vocal, however. Through the 1940s, the Croton Heights Association engaged the railroad in a series of correspondence requesting basic repairs, improvements, and maintenance to the structure. The association had the support of 51 residents who signed a petition asking for some action on the part of the railroad. "It might interest you to note," reads a letter dated August 20, 1947, "that we have twenty-eight regular riders, over half of this number being daily commuters. This is more than any other station north of Elmsford."

The present passenger station in Yorktown Heights was built by the railroad in 1888. Today, it is listed on the local, state, and National Registers of Historic Places. After the station was closed in May 1958, it was put up for sale by the railroad in 1960 and was purchased by the town in 1966. In 1974, the town fathers considered moving the depot to the center of town for use by commuters riding the bus. The idea was abandoned in 1975, and steps were taken to preserve the depot in its original location for the bicentennial celebration. The building's interior was renovated in 1976 by a consortium of people headed by the late George Groht, head of the Landmarks Preservation Committee. It served as an office for the local chamber of commerce until a fire on June 27, 1980, ruined the interior of the building. The exterior was later stabilized and refinished, and in 1999, the refurbished grounds around the depot were rededicated as a town park. A historic preservation architect has been retained by the town to renovate the depot as a concession and gallery along the North County Trailway.

Many residents may remember the old rusty caboose that languished in front of the depot for years. It was purchased and donated to the town by developer Dave Bogdandoff in 1976. The car was an all-steel caboose, built in 1916 for the Pennsylvania Railroad. Since the caboose had little historical connection to the area, it was donated to the fledgling Danbury Railway Museum in 1997, where it is currently undergoing restoration.

Arthur Dunning was the Yorktown Heights station agent for 25 years and worked at various other stations on the Putnam Division during his tenure, according to an August 1961 newspaper article, written about him when he was 82. A lifelong resident of the area, Dunning served for many years on the town zoning board and oversaw much of Yorktown's early development. His father, Charles Dunning, was Yorktown's first fire chief, and his brother Ed Dunning served as town clerk.

Ed Washburn (four generations of the Washburn family worked for the railroad) was another resident with ties to the railroad. Washburn was a regular engineer on the Putnam Division and also had the honor of heading the last steam run to New York in 1951.

Evert "Augie" Berg of Upland Drive was the engineer on the last freight run to Yorktown in 1962. According to newspaper accounts, Berg had a 50-year career on the railroad, although it is not clear how much longer he worked after the article was published in 1962.

The Put remained a testament to older times in a world of modern railroading. Small steam engines ran trains on a single-track main line, on timetable and train order authority, past stations lit with kerosene and equipped with Morse code telegraph keys. Through the postwar

years, many railroads sought to realize savings by switching from steam to diesel locomotives. Diesels did not require the extensive servicing facilities and numerous employees that kept steam trains running.

On Saturday, September 30, 1951, the last steam run on the Putnam Division departed from Yorktown Heights. Charles H. Baker, the Yorktown Heights stationmaster, handed up the orders to engineer Washburn. At exactly 4:05 p.m., the last steam train headed south toward the Bronx. Once steam had left the Put, the service facilities at Yorktown were dismantled.

When the railroad announced its intention to end all commuter service on the Put, concerned commuters spent $35,000 in legal fees fighting the decision. The New York State Public Service Commission refused to hear any arguments on its decision to allow the New York Central to discontinue service. The last passenger run over the Putnam Division was Train No. 947, leaving Sedgwick Avenue in the Bronx on Thursday, May 29, 1958. Extra cars were added, as many turned out to bid the Put a fond farewell. Children waved from trackside, while passengers sang "Auld Lang Syne." After the last run, commuters had the choice of taking a train on another line or driving themselves.

The railroad remained intact for several years after 1958, serving the few freight customers along the line. Declining traffic spelled the end for the Put. Yorktown Heights held ceremonies for another "last" on the Putnam Division. The last freight delivery while the Put was intact was a carload of lumber to the old Creed Brothers Lumber Yard in September 1962. Yorktown resident Evert Berg was the engineer on that run.

After September 12, 1962, the railroad left Yorktown forever. In November 1962, a private contractor removed the tracks between East View and Lake Mahopac. The state of New York purchased the right of way in 1963 to use for improvements to Route 100, and for other uses. Besides the historic railroad station, all that remains is the turntable on the west side of the North County Trail.

Today, almost the entire length of the former Putnam Division can be hiked or biked as part of the North County Trailway. Markers are posted along the way, pointing out locations of depots and other items of historic interest. While the rails are long gone, one can still enjoy the idyllic splendor along the route of the Old Put and imagine what it was like to hear the whistle echo through the valley.

—Otto M. Vondrak

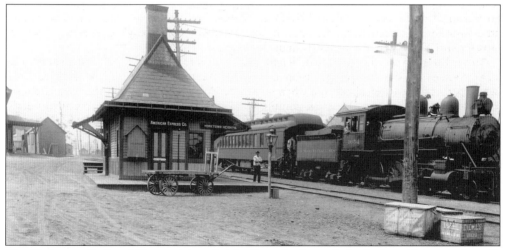

The Yorktown Railroad Depot, a stop for the Put, also housed the Railway Express telegraph office, located on Commerce Street *c.* 1900.

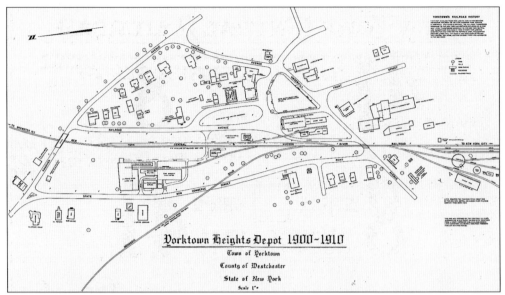

This map dated 1900–1910 shows Yorktown Heights and the train depot. The first main line railroad tracks were laid in 1870 by the New York and Boston Railroad Company acquired from Edward B. Underhill and Silas C. Whitney. The railroad transferred ownership to the New York & Northern Railroad Company in 1880 and then to the New York Central and Hudson River Railroad in 1902, at which time land was acquired for the yard and the Mohansic Spur. The company operated lines until 1917, when it was taken over by the New York Central Railroad, Putnam Division, which was abandoned in the late 1950s.

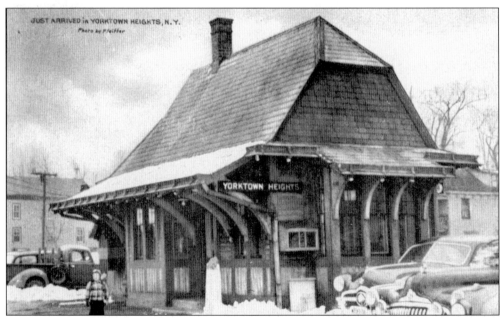

The Yorktown Railroad Depot is a National Historic Landmark. This photograph was taken in early 1940s.

NEW YORK CENTRAL RAILROAD

THIS TICKET GOOD ONLY WHEN SIGNED BY PURCHASER AND PRESENTED IN CONNECTION WITH
HOLDER BEARING PHOTOGRAPH AND SIGNATURE OF PURCHASER AND IS FOR THE INDIVIDUAL
AND EXCLUSIVE USE OF SUCH PURCHASER BETWEEN **NEW YORK (G.C.T.) and**

41 **8**

Form M C 3

(Via High Bridge)

OPTIONAL PRIVILEGES

New York and _Peekskill_ New York and _Yorktown H._
(HUDSON DIV.) (PUTNAM DIV.)

New York and _Katonah_
(HARLEM DIV.) □ **DURING THE** □ **MONTH OF 41**

8 **AUGUST, 1941 41**

M _C. H. Jester_

(PURCHASER) _J H Baird_
 Gen. Pass. Traffic Mgr

This commuter pass was issued by the New York Central to Yorktown resident C.H. Jester for the month of August 1941.

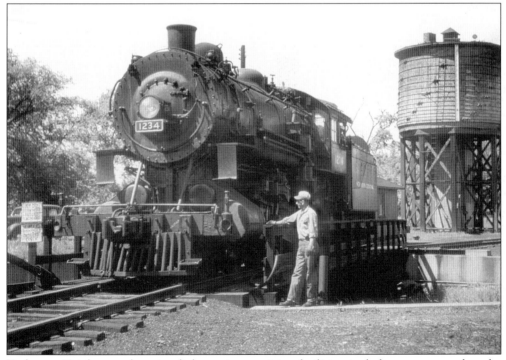

Yorktown Heights was home to light-engine servicing facilities, including a water tank and a turntable. Engine No. 1234 is pictured on the turntable.

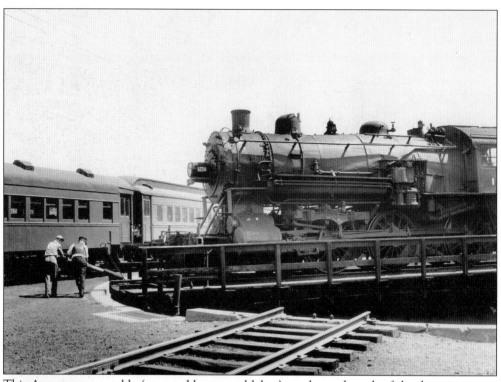

This Armstrong turntable (powered by manual labor) was located south of the depot.

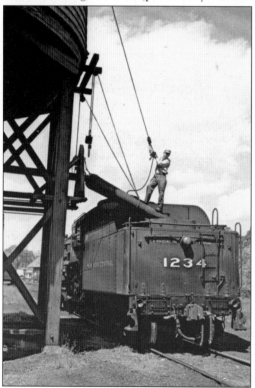

Engine No. 1234 gets some attention in the yard at Yorktown Heights. The engine crew member positions the large water spout into the water tender's open hatch to deliver thousands of gallons of water, used to make steam.

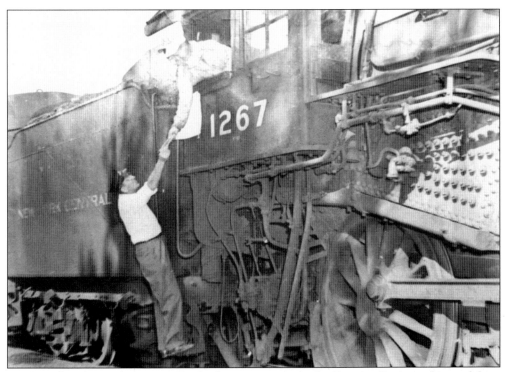

On Saturday, September 30, 1951, the last steam run on the Putnam Division departed from Yorktown Heights. Engine No. 1267 had the honors, run by Yorktown resident Ed Washburn. Yorktown Heights stationmaster Charles H. Baker handed up the orders to Washburn, and at exactly 4:05 p.m., the last steam train headed south toward Sedgewick Avenue terminal in the Bronx.

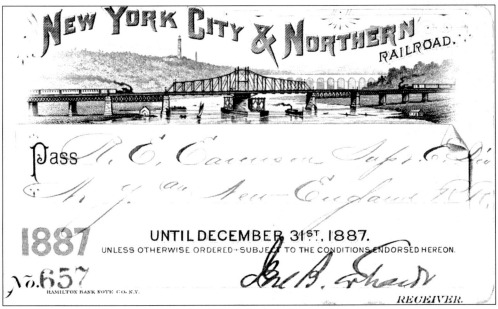

This is a complimentary pass issued by the New York City & Northern Railroad, the company that owned and operated the Put before the takeover by the New York Central in 1896.

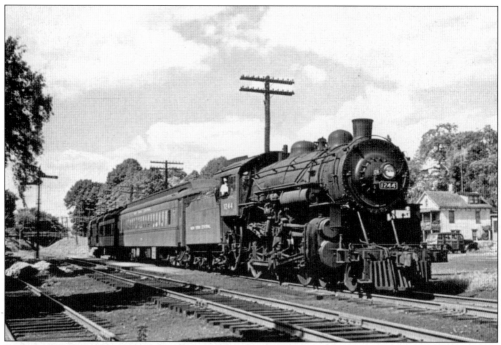

Engine No. 1244 enters Yorktown Heights Station with a midday two-train car. Trains on the Put rarely had more than two or three cars.

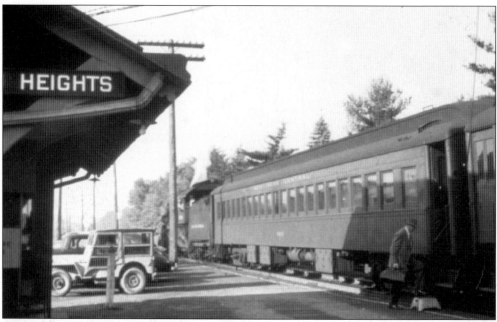

The last commuter boards a morning train bound for Sedgewick Avenue in the Bronx. Commuters for New York had to change to the Hudson Division at High Bridge to get to Grand Central. Many commuter trains originated and terminated at Yorktown. This photograph was taken in June 1951, when steam power was retired on the Put.

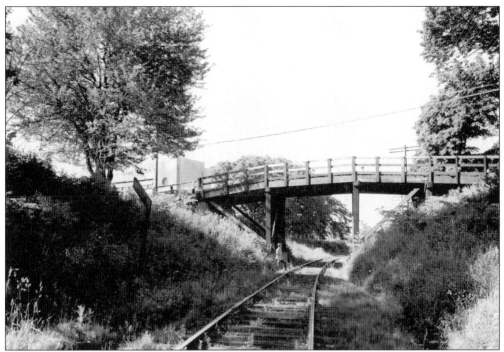

This 1950s view, looking north up the Putnam Division track, shows the old wooden bridge that Hanover Street crossed. Just to the left is the new firehouse.

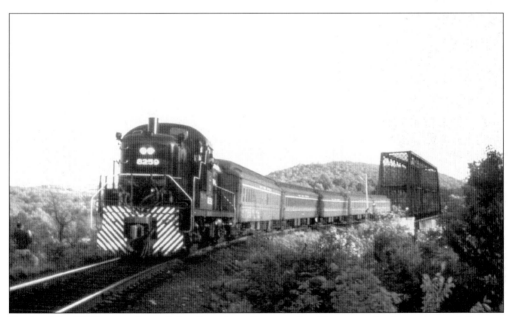

Engine No. 8259, a product of the American Locomotive Company, leads an unusual five-car train over the Croton Bridge, heading for Yorktown Heights and the eventual end of the line at Brewster.

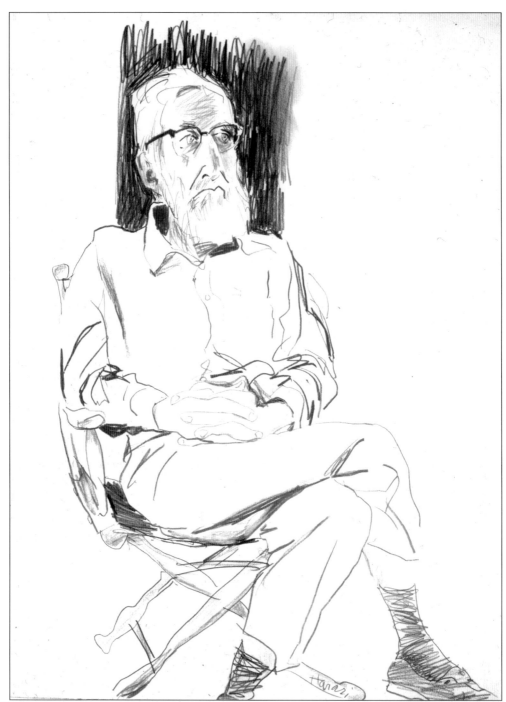

This portrait of Wallace Putnam was drawn on July 27, 1977, by his artist friend Hananiah Harari of Croton. Harari drew it while Putnam and George Kelly, another local artist, were watching a baseball game in Putnam's home on Baptist Church Road. (Courtesy of the artist's wife, Shirley Lewis and Francis M. Naumann.)

Five

SOME NOTABLES

ON BAPTIST CHURCH ROAD

Many fascinating people have made their homes in Yorktown. Yorktown Heights is adjacent to Croton-on-Hudson, a town famous for its community of politically and socially conscious artists. In Yorktown, Baptist Church Road was the hub around which the arts grew. This scenic, meandering road was home to an impressive list of artists, including Consuelo Kanaga, a photographer; Kanaga's husband, Wallace Putnam, a mystical painter; William Maxwell, author and editor of the *New Yorker* magazine; Jean Dancereau, the Canadian-born pianist and teacher; Dancereau's wife, Muriel, a noted opera singer; Leon Fleischer, a pianist famous for playing with one hand; Lawrence Treat, a writer who penned dozens of mystery books; Treat's wife, Rosie, who made surrealist collages, using seaweed; and Rhoda Blumberg, the Newberry Award–winning children's book author.

These artists were friendly with each other and lived in close proximity, forming a tight-knit community. They held parties, luncheons, and get-togethers in this colorful and creative section of Yorktown. Kanaga and Putnam lived in a converted icehouse that they had purchased, with land, in the 1940s for $50. In addition to his devotion to painting, Putnam learned to build stone walls, and he and Kanaga created a unique stone fireplace. Originally, both worked and lived in New York City. They came up to Yorktown on weekends and finally made it their permanent home in 1950. Kanaga, famous for being part of the historic group of photographers (which included Edward Weston and Ansel Adams) was one of America's first photographers to show the inherent beauty and dignity of African Americans through photography. Edward Steichen, "the Dean of Photography," was curator of the landmark 1950s Museum of Modern Art Show "The Family of Man." His favorite photograph of the show was Kanaga's *She Is a Tree of Life Among Us*, which depicts a strong Floridian black woman and her two clinging children. Putnam painted for more than 70 years. A 336-page book detailing Putnam's work and life, titled *Wallace Putnam*, by Francis Naumann (Abrams), was published in 2002.

There were parties, luncheons, and get-togethers in this supportive artists' community.

—Stuart Friedman

YORKTOWN'S "THEATER DISTRICT"

Today, everyone knows the southwest corner of Yorktown as the home of Teatown Lake Reservation. Decades ago, in the years between the two world wars, the area had quite another identity. Remote from the public but accessible to the city by automobile and three rail lines, it was the chosen sanctuary of a number of stars of the New York stage, screen, and radio.

Blinn Road and Illington Road are part of the area's enduring legacy. Blinn Road is named for Holbrook Blinn, a San Franciscan who came east to conquer first the theater and then the new medium of film. Between 1872 and 1928, he performed in and/or directed 36 productions on the legitimate stage and acted in 21 films. In 1910, he formed a New York stage company. Blinn's stage training, good looks, and gift for makeup transformation made him a natural choice for film producer Lewis Selznick and his newly formed (1915) Republic Selznick-Select Company. Blinn had a busy career in the silent films, appearing with favorites such as Mary Pickford and Marion Davies. However, he never made it to talkies. In June 1928, at the age of

56, he died unexpectedly after a horseback riding accident. Local legend has it that Blinn was thrown from his horse as he rode from his estate to the nearby home of a mistress. That estate is now called Will-o-Woods. The rocky road he descended to what became Blinn Road is now Journey's End. Therein lies another tale or rather mystery, as *Journey's End* is the title of a powerful antiwar play performed in London in 1928 with a then unknown actor named Laurence Olivier. A year after Blinn's death, the play came to New York. Whatever the relationship between Blinn and the play may be, it is not, as another appealing legend would have it, that of an actor and his final stage role.

Both Margaret Illington and her Yorktown estate have rich and dappled histories. Born in Illinois in 1881, Maude Light went west, became the actress Margaret Illington, and made a second marriage to real estate investor Edward Bowes. After the San Francisco earthquake and fire in 1906, the couple moved east and acquired theaters in Boston and New York City. Between 1902 and 1919, Illington appeared in a new play almost every year. Like many of their New York theater friends, the couple chose the Yorktown-New Castle neighborhood for a country seat. Unlike most of their friends, they acquired two rather grand country seats: Laurel Hill, a 10-acre estate on Allapartus Road in New Castle, conveyed in 1927 to Edward Bowes, with a laurel display that is still outstanding; and nearby Dream Lake Farm, in Yorktown, titled to Illington, who shared her husband's home until her death at 52 in 1934. She did not live to see it destroyed by fire in 1937. More importantly, she did not live to witness her husband's rise to fame in 1934 as host of *Major Bowes' Original Amateur Hour*, the most popular program on radio for 12 years. Dream Lake Farm proved to be a headline maker. In a raid just before Easter 1930, state police and federal agents found, according to the *Citizen Sentinel*, "$10,000 worth of equipment . . . 3,000 pounds of brown sugar; large vats and mash," Prohibition's equivalent to acres of marijuana plants. Illington was notified, and her lessee was charged.

The next owner of Dream Lake was Lester Hofheimer. His tenure was uneventful, as was André Mayer's, until a sale proposed in 1958. The purchaser was the Wiltwyck School, an Esopus establishment seeking to move closer to New York City. When the school sought a zoning change to build quarters for troubled boys who had been remanded by New York City courts, headlines blazed and opposition flared. After 12 years of court battles, Wiltwyck won the battle and construction began in June 1966. The 114-acre Wiltwyck School campus was formally dedicated. The ensuing decade, with its civil rights unrest, Vietnam War, changing social service practice, and budget crises, did not favor the school. In August 1977, a local headline declared, "Wiltwyck Yorktown Campus to Close." Four years later, the institution was shut down. Two years after that, the property was auctioned off in bankruptcy court to a Manhattan real estate firm for $1.3 million. Not long afterward, the former Dream Lake Farm was sold for $1.4 million to Pupa Hasidim, a Brooklyn-based Hasidic sect, which is still in residence.

As recently as 2002, neighbors in Yorktown's erstwhile "theater district" thronged to a public meeting to protest the conversion of a small barn on Blinn Road into a part-time theater. The professional actors may be long gone, but the drama continues.

—Barbara Walker

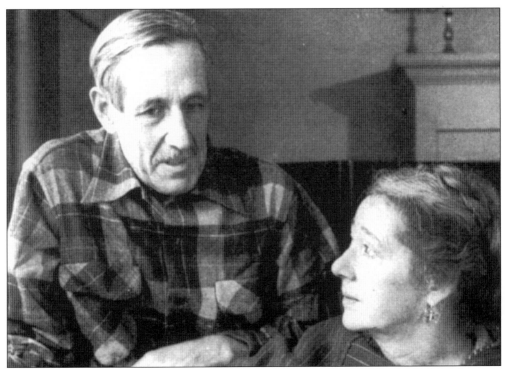

Wallace Putnam and his wife, Consuelo Kanaga, are shown in 1961 at their country home, a former icehouse on Baptist Church Road. In 1950, they left Manhattan and moved to Yorktown. Putnam's adjustment was easy—he simply painted the birds, deer, and other animals, as well as the couple's friends, who came to the magical icehouse and pond. (Photograph by Amber Hiken.)

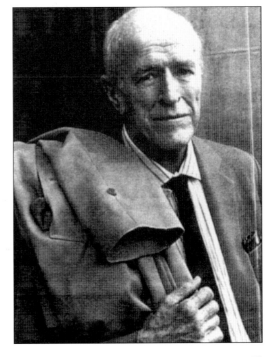

William Maxwell was a noted author and former editor of the *New Yorker* magazine. (Courtesy of James Wade.)

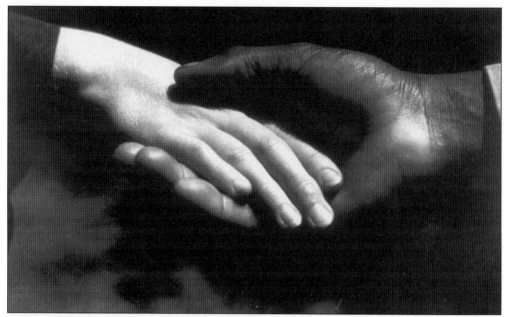

For Consuelo Kanaga, the adjustment to her new surroundings was less easy, but she still maintained her sharp ability to create beautiful transcendent photographs, such as this one, "Hands" (1930). She decided to do portraits, and many of the local neighbors were her subjects. (Courtesy of the collection of Cornelia Cotton.)

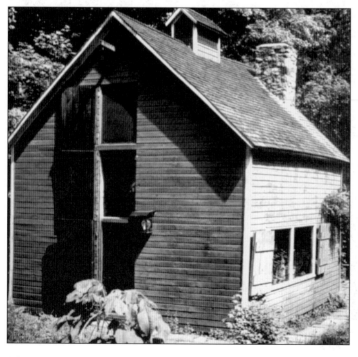

Shown is the Baptist Church Road icehouse that was the country home of artists Wallace Putnam and Consuelo Kanaga. (Photograph by Amber Hiken.)

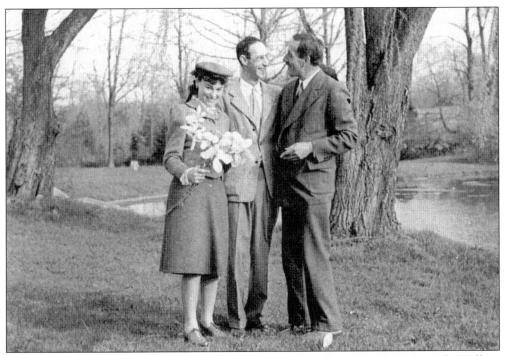

Rosie and Lawrence Treat are pictured on their wedding day, May 7, 1943, with Wallace Putnam (right), who was best man. They are on the grounds of Judge Beaver's Underhill Avenue home. (Photograph by Consuelo Kanaga.)

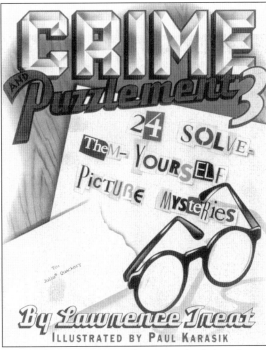

Rosie Treat (left) creates one of her surrealistic collages in 2001. The cover (right) is that of one of Lawrence Treat's last books.

SPORTSMAN'S ESTATE
With Beautiful Private Lake

ONE of Westchester's most picturesque country Estates has just come on the market. This property contains 112 acres of beautiful woodland surrounding an exquisite private lake well stocked with fish, containing bathing floats, boathouse and other facilities for water sports.

The residence, which is of fireproof construction, is most artistically designed. There are beautiful porches overlooking the lake, splendid living rooms, including paneled billiard room, and from the dining room splendid views of the lake are obtained. The pantry, kitchen and servants' dining room are tiled. There are 4 master bedrooms, 2 dressing rooms, 2 sleeping porches and 4 master baths; ample servants' quarters. The house embodies every modern convenience, including oil heat. The main residence is surrounded by landscaped terraces, pools and flower gardens. There is a guest cottage of 5 rooms and bath on the lake shore; farmer's cottage of 7 rooms and bath, stable and outbuildings.

This property is being offered for the first time at a very reasonable figure.

GEORGE HOWE, Inc.

Tel. Vand. 7203 521 FIFTH AVENUE New York City

Shown is a detail from a real estate advertisement for Holbrook Blinn's estate, on Journey's End Road. (Courtesy of Edward and Zita Rosenthal.)

The following account is from "Life in the Mansion," the unpublished memoir of Lillian Dollar Tompkins, the daughter of Russell Dollar, Holbrook Blinn's former estate manager: "Mr. and Mrs. Blinn did quite a bit of entertaining, especially during the Summer when he was not on Broadway. There were many well-known names on their guest list: Irving S. Cobb, Jeanne Eagles (who lived just outside of Ossining), Fay Bainter, who lived in a lovely English Tudor when she wasn't in Hollywood, Major Bowes, who lived a couple of miles outside of Ossining atop a 'mountain,' access to which was up a very steep road (Allapartus Road). In those days, Westchester was the 'home' of the show business people, long before the exodus to Connecticut which started in the late 1940s. . . . Mr. Blinn, an excellent horseman, had acquired a new horse. He wanted to try this one out and he set out for a trip around the neighborhood. As far as anyone knows the story, he wound up near the Sherbloms, dismounted to pick some iris and, when remounting, the iris stalks pricked the horse. The horse threw Mr. Blinn to the ground, causing a minor cut to the upper forehead and then stepped on Mr. Blinn's upper arm, gouging out a hunk of flesh. The horse left Mr. Blinn lying in the road—dirt, at that. Mr. Blinn was transported to his home by the Sherblooms. Mrs. Blinn, instead of calling an excellent doctor from Ossining, a larger and more advanced town, called the Croton doctor. He came out, barely attempted to cleanse the wound, stitched it up and left. In a very short time, infection set in and, by the time a more qualified doctor was called in, the arm was in terrible shape. Mr. Blinn, who loved that lake like it was heaven, said that they should amputate, if necessary, but he wanted nothing more than to get into the lake and float around. He used to float around out there with a cigarette in his mouth. However, they finally called in a man to give Mr. Blinn a direct blood transfusion. That did no good, and a week after the accident, Mr. Blinn was dead." (Courtesy of Bruce Dollar, nephew of Lillian Dollar Tompkins.)

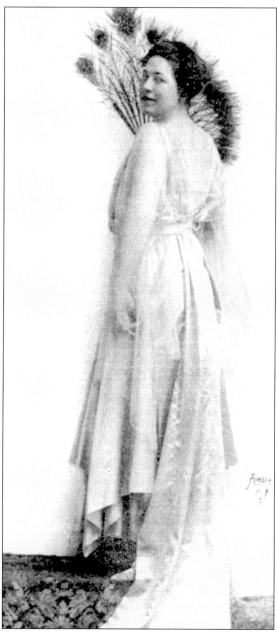

In 1916, opera singer Lydia Locke, a member of the London Opera Company, bought a 1,000-acre estate, which she named Locke Ledge. The estate included a 26-room mansion (destroyed in the fire of 1966) and a private chapel. It was situated on Route 118 between Yorktown and the Croton Reservoir. Today, a part of the property is owned by the Sanctuary Golf Club. According to local residents of that time, Locke picnicked on Turkey Mountain with the famous tenor Enrico Caruso. She was said to have entertained several presidents—Woodrow Wilson, William Howard Taft, Warren G. Harding, and Calvin Coolidge—as well as other heads of state, including a Georgian pretender to the throne of Russia. She had seven husbands, including Lord Reginald Talbot, whom she shot in the chest with a gun hidden in her muff. She stood trial for Talbot's murder and was acquitted on the grounds of self-defense.

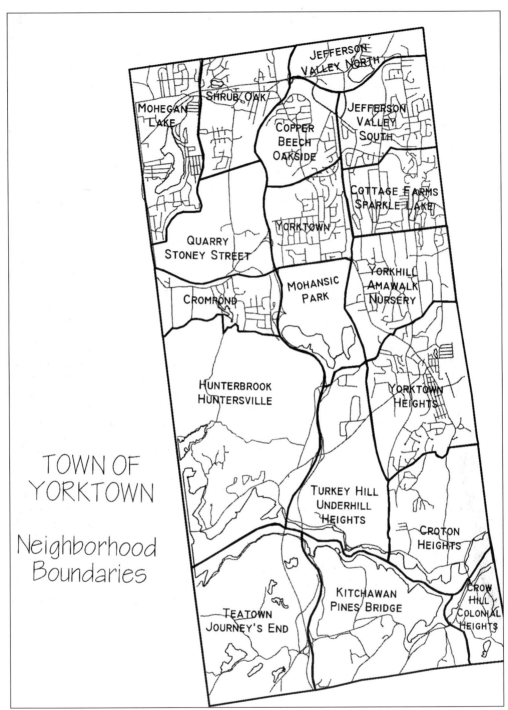

This is a map of the hamlet and neighborhood boundaries of Yorktown. The designation of "hamlet" applies to the five separate areas of commerce in Yorktown, and that of "neighborhood" applies to a residential area with distinguishing characteristics. (Prepared by Robyn Prestamo, Yorktown Planning Department, 2003.)

Six

THE HAMLET OF YORKTOWN

Like all of Yorktown, the Heights were part of the vast Van Cortlandt estate made up of 86,000 acres stretching from the Croton River to Connecticut. Stephanus Van Cortlandt obtained his lands in 1683. After his death, his holdings were divided among his heirs and the estate was divided into lots. By the early 18th century, the area had fewer than 100 settlers, but by the middle of that century, it had attracted immigrants who were establishing homesteads. Before the century was out, it had become an important host to the French Revolutionary War allies.

Primarily agricultural during the post–Revolutionary War period, the area's development was boosted by the introduction in 1870 of a railroad line that originated in New York City. The line traversed the Putnam Valley and continued to Brewster, linking to lines farther north. The Yorktown Heights Station was constructed in 1888, and in 1896, it was bought by the New York Central Line and became known as "the Old Put." After the railroad was built, businesses began to move closer to the railroad plaza, and area farmers began shipping their milk by rail. Yorktown Heights became the new municipal and commercial center of Yorktown. In 1909, Yorktown Engine Company No. 1 was established. After a few hundred dollars was raised, the firehouse was erected at Maple Court and a hand pump was purchased.

With the closing of the downtown station in 1958, nearby businesses declined and the Heights was subject to what had become common in postwar America: the downtown lost businesses and became surrounded by strip malls and shopping centers. The formation of the Town Urban Renewal Agency in 1966 spelled the end of an era for the downtown area. Underhill Apartments, on Railroad Avenue, and the Underhill Plaza, on Commerce Street, were built. Subsequently, Underhill Avenue and Commerce Street were realigned, the Outside Inn vanished, and Mitchell Hardware was relocated. Although detractors denounced the resulting "hodgepodge," others applauded the new commercial cornerstone created by Underhill Plaza.

The trend of unlimited expansion waned in the 1970s as concern about the environment, open space, and preservation grew. The new awareness brought improvements to Yorktown's center, such as the Yorktown Community and Cultural Center, housed in the old Commerce Street School. Once abandoned, it later became home to the Yorktown Planning Department office, nutrition and teen and day care centers, a dance school, Yorktown Stage, and the Yorktown Museum.

In 1999, Railroad Park was refurbished and rededicated as a town park. Today, the old depot, which partially burned in 1980, is scheduled for restoration, and North County Trailway users in-line skate, bike, and hike along the path of the old railroad bed, accessing the park via interconnecting paths, drawn to its brick and wrought-iron promenade and benches.

—Susan Chitwood

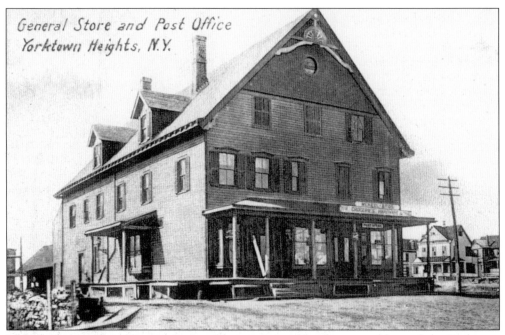

The McKeel Brothers General Store sold groceries and hardware, and housed the Yorktown Heights Post Office. Upstairs was Tompkins Hall, a large room used for meetings and social functions. (Courtesy of Dolores Pedi.)

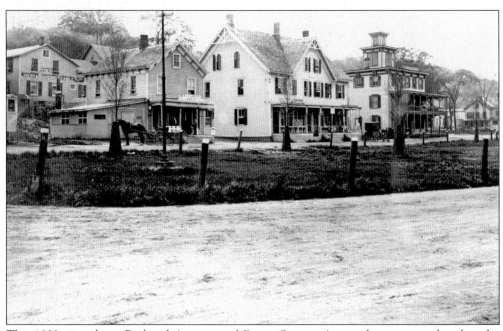

This 1909 view shows Railroad Avenue and Depot Square. Across the grassy oval and to the right is the Whitney House, a hotel.

The Whitney House, located across from the Yorktown Heights Station, was opened in 1882 by Ezekial Palmer. It was named after local landowner Silas Whitney. A three-story structure, it had accommodations for 20 guests. A hall located at the rear of the hotel was used for meetings and social activities. Elections were held here, as were dances and even church services. The hotel was a frequent stop for dairy farmers shipping their cargo of milk to the city by train. By the 1900s, the Whitney House was taken over by Joe Carpenter, who ran a saloon and hosted wedding receptions. In the summer, the Yorktown Band played on the upper porch to an audience that gathered in the park across from the hotel.

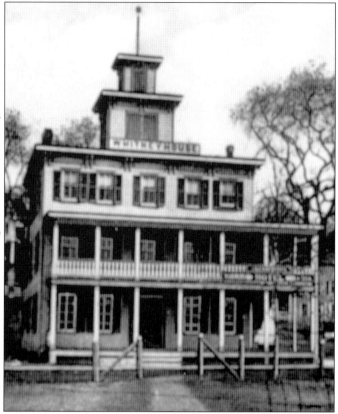

The Friends Church (now the Calvary Bible Church) and parsonage on Hanover Street look almost the same today as they did when this photograph was taken in the early 1900s.

Built in the 1880s and used until 1923 for grades one through eight, the Yorktown Heights public school was located on Hanover Street and Church Street. This is where St. Patrick's Roman Catholic Stone Church stands today. Two members of the Strang family recall life and school days in the first half of the 20th century. "There were more cows than people," according to Clark Strang, who was born on April 19, 1929. "There were fewer than 20 homes on Route 132," where his grandfather owned a farm. During his teenage years, Strang was up by 5:00 a.m., feeding the cows before heading off to school. The school population at that time was so small that six-man football teams were the norm. "There weren't enough kids to have the usual eleven-man squad." At lunchtime, he and his buddies would cross the street and buy a sandwich and a Pepsi for a quarter. He credits his mother with his perfect 12-year attendance at Sunday school. The children of the neighborhood all called her Mom. Joan Strang was 15 years old when her parents moved the family from Brooklyn to Yorktown in the 1940s. Her parents worked as farmhand and cook at Cristal Farm, on Hanover Street. "Yorktown was a small town. Everyone was friendly and knew one another." Mildred Strang was the principal of the local school, now known as the Yorktown Community and Cultural Center, on Commerce Street. Her most vivid memory is of coming into town on the train known as the Old Put. Looking back, she wishes her children could have experienced growing up during the days when people were friendlier.

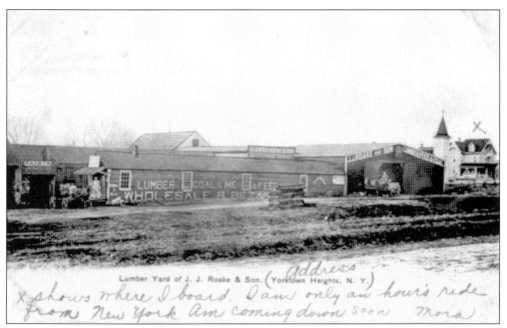

Lumber Yard of J. J. Roake & Son. (Yorktown Heights, N. Y.)

X shows where I board. I am only an hour's ride from New York. Am coming down soon. Mora.

This is the lumberyard of J.J. Roake and Son (later, Creed's), on what is now Commerce Street opposite the Yorktown Commons. The church on the right and in the picture below is St. Peter's Catholic Church, built in 1898 on the site of the current Rexall building. (Courtesy of Dolores Pedi.)

As the Catholic population in Yorktown grew, this church was no longer large enough. In 1933, work began on the stone church on Hanover Street, which was renamed St. Patrick's Church. Joan Romano, now a year-round resident of Yorktown, spent the summers after World War II with her relatives who lived near the old St. Patrick's Church, on Hanover Street. "What I remember most about Yorktown was that it reminded me of the Wild West. There were no streets. There were no sidewalks. When I went inside my Uncle Perry's store, you had to walk along wooden planks. I remember walking amongst the tomato plants with a salt shaker in my back pocket. Uncle Jim would chase me with his cane after I threw pebbles through the chicken wire at his chickens. I remember my aunt was always making dishes with fresh chickens, and with that came eggs. They lived on whatever they planted because times were tough."

Yorktown's first firehouse was located on Commerce Street on the same site as the current fire department. In the wooden tower (right) hung a large bell that was used to summon the volunteers. This photograph was taken *c.* 1926.

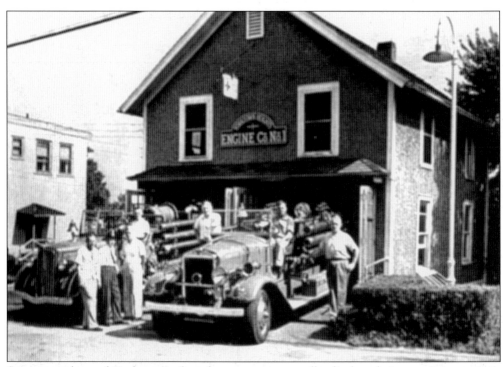

Seven members of Yorktown's first fire company proudly display their two Reo engines. Yorktown Engine Company No. 1 was organized in 1909, when the town had a population of 3,000.

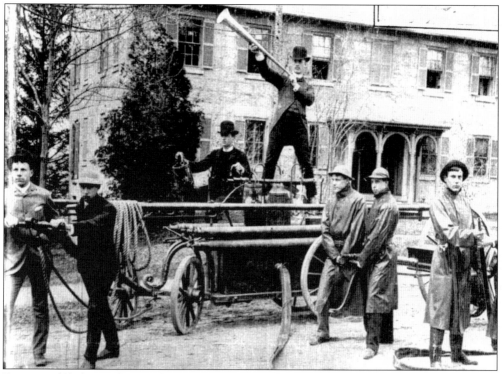

Firemen of Yorktown Engine Company No. 1 pose for a photograph in 1909.

The mascot of Engine Company No. 1 sits at the wheel, prepared for action.

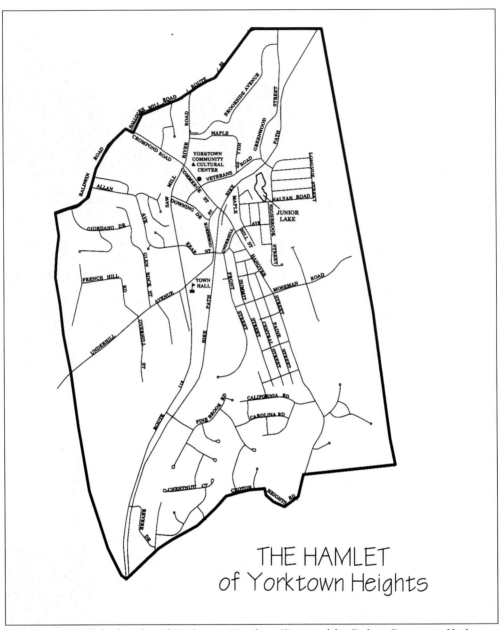

This is a map of the hamlet of Yorktown Heights. (Prepared by Robyn Prestamo, Yorktown Planning Department, 2003.)

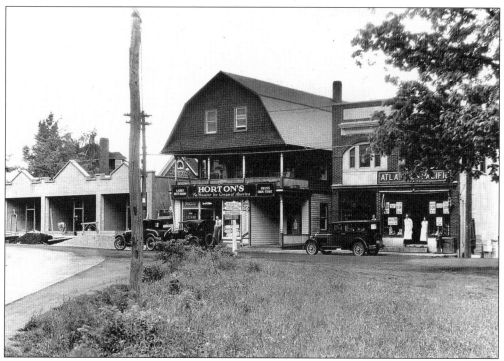

This 1926 view of Commerce Street shows the area near the current Yorktown Heights firehouse. Pictured are Horton's and the A & P.

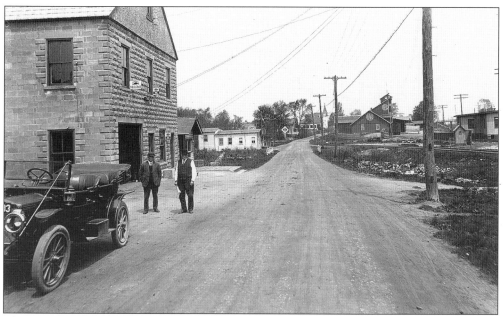

This view shows Dunning's Garage, on Commerce Street, with John Seymour (left) and Henry C. Kear (right).

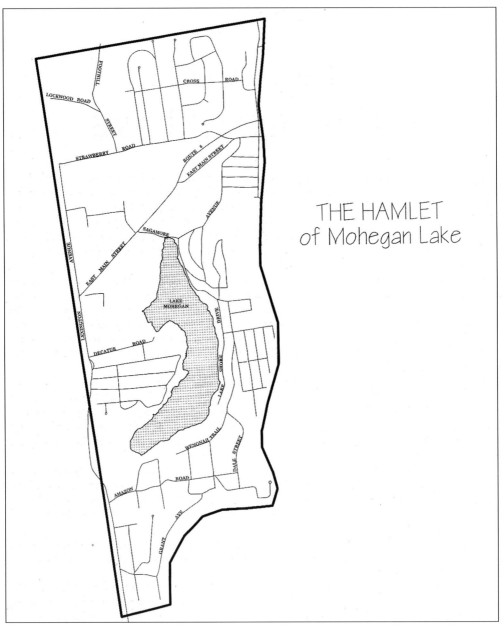

THE HAMLET
of Mohegan Lake

This is a map of the hamlet of Mohegan Lake. (Prepared by Robyn Prestamo, Yorktown Planning Department, 2003.)

Seven

THE HAMLET OF MOHEGAN LAKE

Long before Mohegan Lake became a popular summer resort in the late 1800s, it was home to the Mohican Indians, a part of the Algonquin nation. These Native Americans predated the 1609 arrival of Henry Hudson—with whom they fought at his epic landing on the Hudson—by centuries. The Mohicans were eventually supplanted by Dutch settlers in the 1600s, and only a few hundred still lived in the area in 1700. During this period, Lake Mohegan was depicted on maps as Crooked Pond, or *Krum-Poel* in Dutch, which became Crompond before changing to Mohegan Lake.

Although the Colonists enlisted the Mohicans to battle the redcoats during the American Revolution, by 1881, most of the native Mohicans had been relocated to Wisconsin for resettlement. The new rail lines to Peekskill and Yorktown Heights brought opportunity and newcomers. Among the latter were summer visitors escaping the city, bound for the pleasures of the Lake Mohegan resorts. On the west shore stood the colossal St. Nicholas Hotel, 324 feet long and six stories high, able to house 500 guests. When the hotel burned in 1908, the fire could be seen as far away as Peekskill.

William Jones, who christened the lake in 1859, built the Mount Palace Hotel on the eastern shore to accommodate 100 guests. His son, Walter Jones, ran the Lakelawn Cottage Hotel in what is today Mohegan Highlands. At the intersection of Strawberry and Lexington Roads, a sea captain who prospered from trading spices from the Far East built an inn in 1852. Later renamed Onofrio's, the inn burned down in 1993. The carriage house behind the inn was the original site of the Mohegan Lake Volunteer Fire Department.

In 1923, a new group of settlers staked claims with the arrival of the Mohegan Colony Association, headed by anarchist Harry Kelly. The original 25 families, seeking an escape from the city, had grown to about 250 families by 1988. A Socialist experiment, the Mohegan Colony had its own school. Colony members paid annual dues to fund recreational and cultural programs.

Today, some 1,500 people live around the 100-acre Lake Mohegan. A yearlong building moratorium and the Yorktown Comprehensive Plan aim to address ongoing development in the area.

"It was just such a great place to grow up. Everyone knew everyone else. If your kid got into trouble, the cop would just bring him home," according to resident Dolly Heady, who moved to the town of Yorktown from the city of Peekskill in 1949. She remembers her daily commute, which began with a walk up the street to the bus stop in her high heels, suit, and white gloves—the uniform for women working in New York City. The Mayflower Bus Line ran from Baldwin Place to the Peekskill Train Station. Barney, the bus driver, would get her to Peekskill in time for the 7:07 a.m. train to New York City, where she worked as an accountant for the railroad, returning from her job on the 6:06 p.m. train. In the summer, when Mohegan Lake teemed with visitors escaping the heat of New York City, the streets became so congested that Barney had a hard time keeping on schedule.

—Susan Chitwood

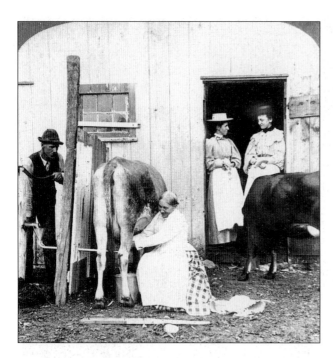

This 1898 photograph shows the milking process before delivery to local customers and distributors. (Courtesy the Lee collection.)

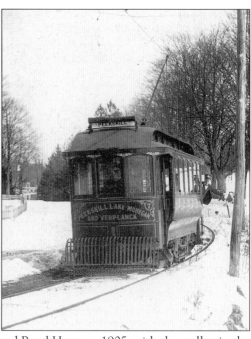

On the left are the Mohegan Lake Post Office and Road House *c.* 1905, with the trolley in the background. On the right, in a different season, is Trolley No. 7, which ran between Peekskill, Lake Mohegan, and Verplanck.

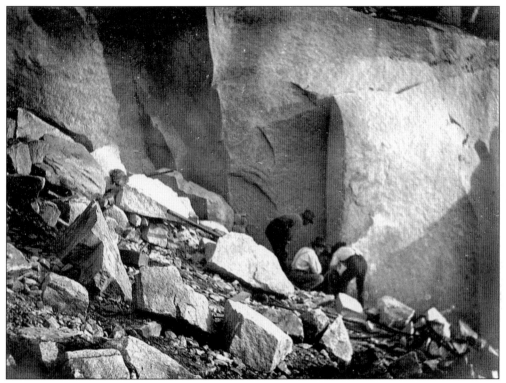

Men work at the Mohegan Lake quarry *c.* 1900. The golden granite was used in Wall Street buildings, for St. John the Divine Church, and on the George Washington Bridge.

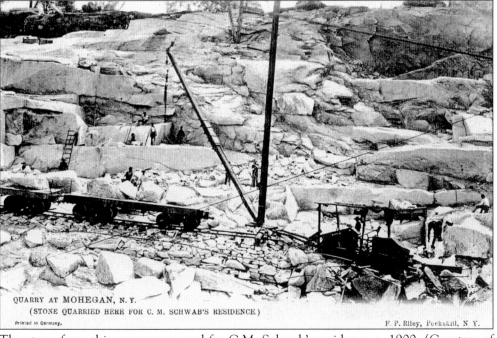

QUARRY AT MOHEGAN, N. Y.
(STONE QUARRIED HERE FOR C. M. SCHWAB'S RESIDENCE.)
Printed in Germany. F. P. Riley, Peekskill, N. Y.

The stone from this quarry was used for C.M. Schwab's residence *c.* 1900. (Courtesy of Dolores Pedi.)

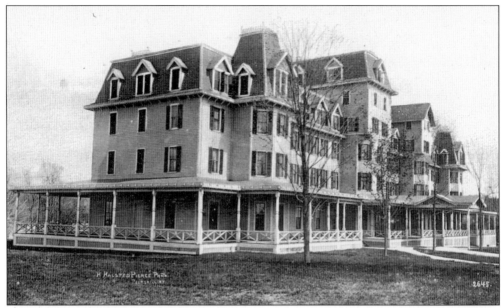

During the late 1800s, several large hotels were built along the lake, attesting to its popularity as a summer resort. Built on the west shore was the St. Nicholas Hotel, owned by Frank Frye. The hotel was large enough to accommodate 500 guests. It was destroyed by fire in 1908.

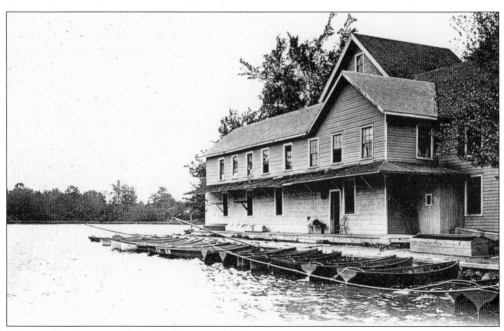

This is a boathouse on Lake Mohegan *c.* 1900.

This is a canoe house on Lake Mohegan c. 1900.

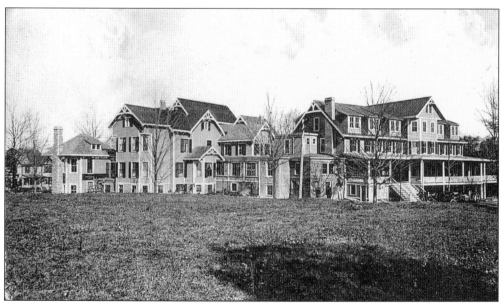

The Mohegan Inn was another popular summer resort hotel in the early 1900s.

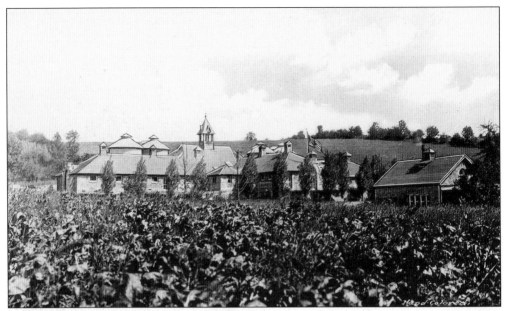

This is the cattle barn and dairy at Mohegan Farm.

Pictured are the Holstein cattle on Mohegan Farm.

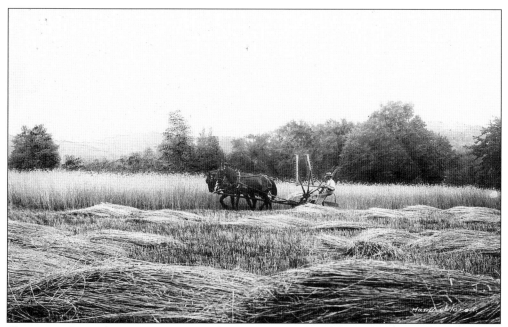

Shown is a farmer harvesting rye on Mohegan Farm.

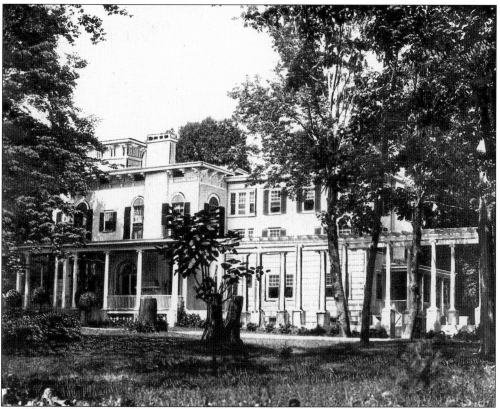

This was the residence of Charles H. Baker, owner of Mohegan Farm. Baker was best known for his company, Baker's Chocolate.

SEVENTH ANNUAL BANQUET
OF THE
MOHEGAN VOLUNTEER FIRE ASSOCIATION
AT MOHEGAN FIRE HOUSE
TUESDAY EVENING, MARCH 4TH, 1930

The Mohegan Volunteer Fire Association organized on February 22, 1922. This is the banquet menu for the association's seventh annual banquet, held on Tuesday, March 4, 1930, at the Mohegan Firehouse.

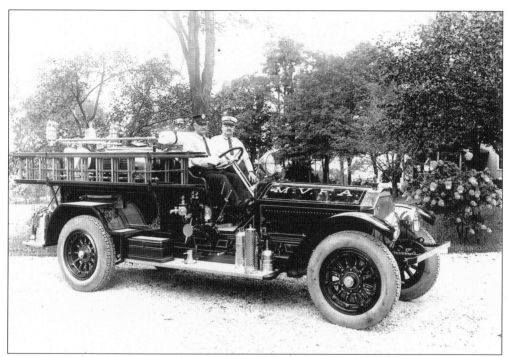

Pictured are members of the Mohegan Fire Association.

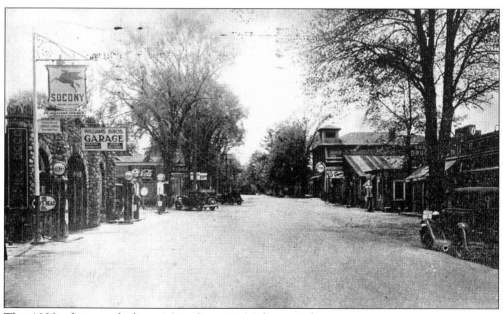

This 1920s photograph shows Main Street in Mohegan Lake.

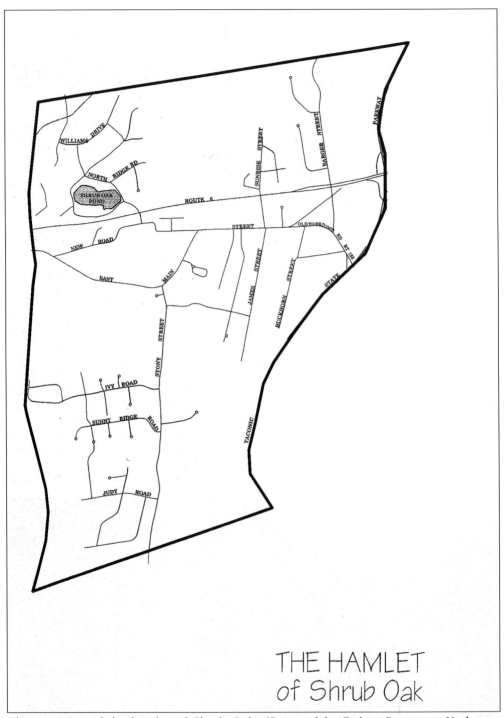

This is a map of the hamlet of Shrub Oak. (Prepared by Robyn Prestamo, Yorktown Planning Department, 2003.)

Eight
THE HAMLET OF SHRUB OAK

The hamlet of Shrub Oak, relatively unchanged in over 100 years, is wedged between the Taconic State Parkway on the east and Strawberry Road on the west. Shrub Oak is distinguished by its Main Street, charming old homes, bucolic green space, and beautiful village center, surrounded by stores and businesses.

Settled in 1686 by Joshua Hyatt, it was known as Hyatt's Plains. During the American Revolution, Shrub Oak saw no action, but the Marquis de Lafayette trained troops at the Hyatt homestead. Spy Maj. John André was brought through the little settlement of eight buildings on his way to Garrison at the behest of Gen. George Washington. André, carrying the plans of West Point given to him by traitor Benedict Arnold, was captured by John Paulding in Tarrytown. Paulding later purchased a house and tavern on Main Street.

One of the county's first Methodist churches was erected in 1789 at the site of the present Denver-Hallock monument. Rev. Francis Asbury, the circuit-riding minister responsible for helping Methodism take hold in America, once preached there. By the latter half of the century, the hamlet was rechristened Shrub Oak Plains, allegedly in homage to Piano Mountain's Shrub Oaks. In 1829, when the first post office went up, "Plains" was dropped from the name.

By the mid-19th century, Shrub Oak was experiencing a boom in new buildings. In 1867, there were 23 structures, including a blacksmith and wheelwright shop, the Willow Brook Preparatory Academy, and William Roake's store, now the delicatessen across from the library. In the same year, Grace Methodist Church was built where abolitionist Rev. Henry Ward Beecher spoke. The area's first Catholic church, St. John's, followed five years later.

By the turn of the century, New Yorkers were building summer homes here, creating the Shrub Oak Lake Community and other similar colonies. These summer residences eventually became year-round homes.

—Susan Chitwood

This sawmill was located on Mill Street in Shrub Oak.

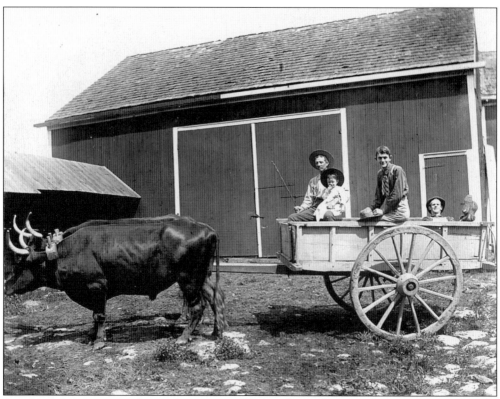

At a local farm, a team of oxen draws a cart filled with people. The photograph was taken by Albert Emmons in August 1901.

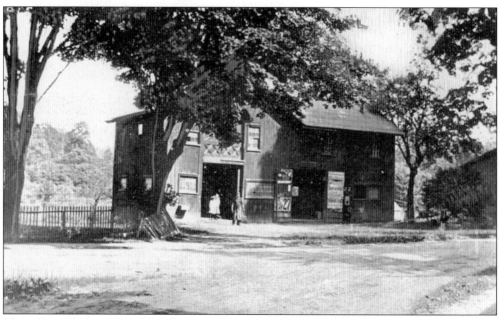

The village blacksmith and his shop were located on East Main Street near Stony Street.

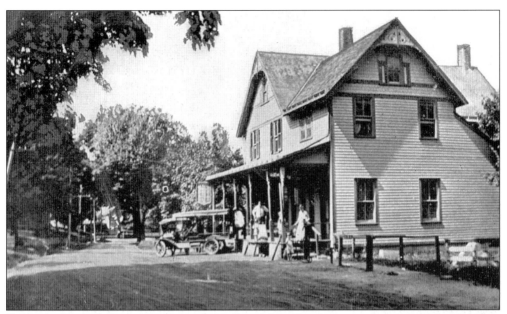

Darrow's General Store was located on East Main Street across from the John C. Hart Memorial Library.

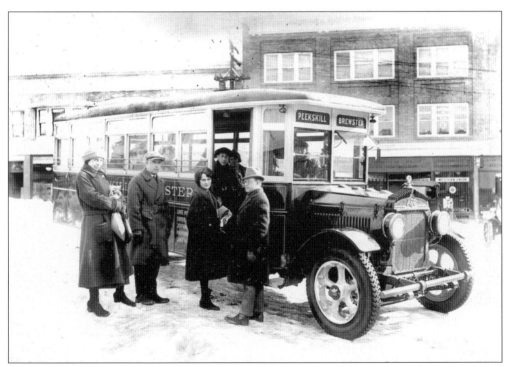

During the winter of 1922, Gladys Clearwater (third from the left) and others prepare to board the bus that ran from Shrub Oak to Jefferson Valley.

During the late 1800s, Shrub Oak was home to a racetrack located at what is now the intersection of the Taconic Parkway and Route 6. The half-mile track was built in 1890 by Charles W. Carpenter, the owner of Sunnyside Farm, to exercise his own horses. Later, Carpenter allowed other farmers to race their horses there, and from 1896 to 1912, the Saturday afternoon races were a popular event for local residents. Spectators came to watch the trotters and pacers. However, no official betting was allowed. The track's popularity declined as automobiles became more widely used and fewer area residents kept horses. In the 1920s, the construction of the Taconic State Parkway brought an end to Shrub Oak's track.

A horse is warmed up for a race.

A horse and wagon passes by the Shrub Oak Methodist Church in the early 1900s.

The Shrub Oak Methodist Church that replaced the earlier wood structure was designed by James William Martens Jr., who moved to Shrub Oak in 1901.

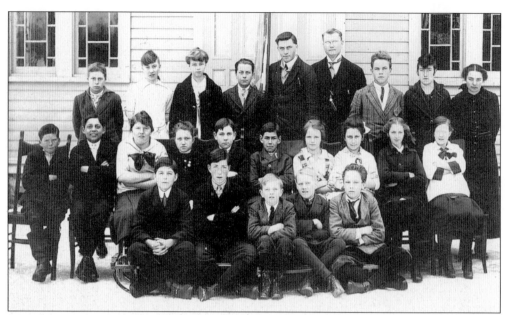

Shown are students in the fifth, sixth, seventh, and eighth grades at the Shrub Oak School c. 1915–1916. From left to right are the following: (front row) Morris Dring, Ralph Crawford, Ira Strang, Hugh Scofield, and Connel Martin; (middle row) John Chadwick, Arthur Jenison, Bessie Chadwick, Mildred Strang, Lea James, Frank Fisher, Grace Banger, Edna Dice, Catherine Archer, and Edna Petrolky; (back row) Bill Gillette, Marjorie Strang, Florence Strang, William Odell, Mike Finnerty, M.E. Powell (principal), Clayton Barger, Lulen Crawford, and Maggie Finnerty.

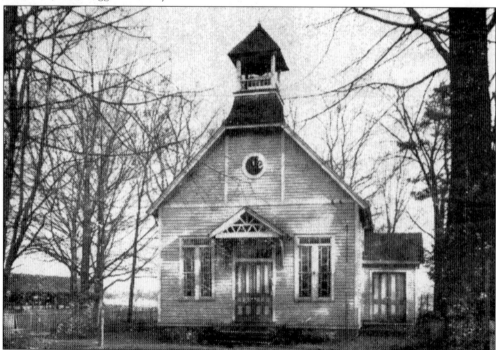

The Shrub Oak School was a two-room schoolhouse.

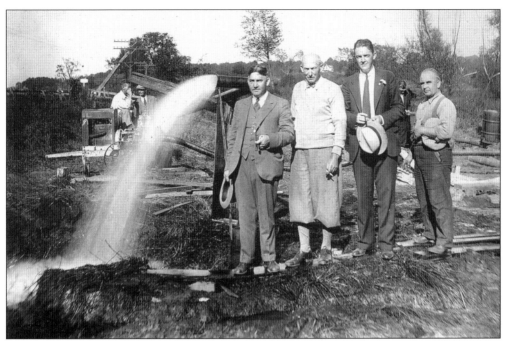

Public water came to Yorktown in 1930. The commissioners of the water board are, from left to right, Samuel S. McBride, Mortimer F. Mckeel, James H. Harding, and Edward L. Dunning.

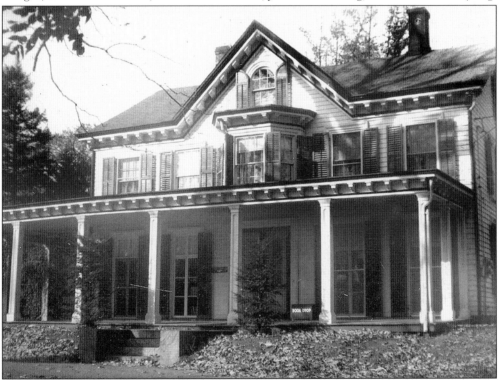

Pictured is the John C. Hart Memorial Library before its expansion in the 1980s. (Courtesy of the John C. Hart Memorial Library.)

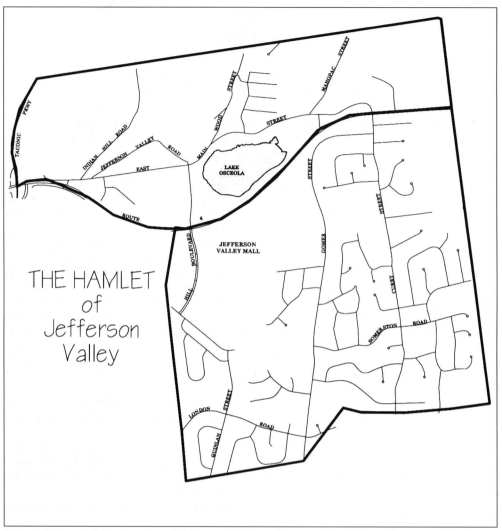

The following labels appear on the map:

THE HAMLET
of
Jefferson
Valley

TACONIC PKWY

INDIAN HILL ROAD

JEFFERSON VALLEY ROAD

EAST

MAIN

WOOD

STREET

STREET

MAHOPAC STREET

LAKE OSCEOLA

STREET

JEFFERSON

ROUTE 6

HILL BOULEVARD

JEFFERSON VALLEY MALL

GOMER STREET

LEFERS STREET

CURRY

SOMERSTON ROAD

LONDON STREET

QUINLAN

ROAD

This is a map of the hamlet of Jefferson Valley. (Prepared by Robyn Prestamo, Yorktown Planning Department, 2003.)

Nine

THE HAMLET
OF JEFFERSON VALLEY

Jefferson Valley was once so bucolic it was known as Sleepy Hollow. It was renamed in honor of the nation's third president by local landowner and physician Dr. Joseph Fountain, whose own horseback house calls took him as far as Washington Irving territory in then far off Tarrytown, north to Fishkill, and from the Hudson River to Connecticut and beyond.

Although recorded history is scant, the native Kitchewanc Indians gradually disappeared, driven out by European newcomers who increased in number after 1734, the year Stephanus Van Cortlandt's manor was divided among his heirs. All of Yorktown was part of his vast domain, a patent he had received from England's King William III in 1697.

Jefferson Valley, or the Great North Lott No. 4, was inherited by Stephanus's daughter Cornelia, who married Col. John Schuyler. The Gomers were said to be one of the first white families to buy land and settle here. They lived in the area that is now crossed by Gomer Street, in southern Jefferson Valley. Other long established families include the Archers, Bargers, Birdsalls, Currys, Lounsburys, Travises, and Wildeys. Jefferson Valley's principal claim to Revolutionary War fame is Maj. John André's passage under guard over Route 6N and Main Street. The spy was en route to Garrison and Gen. George Washington.

The old center of Jefferson Valley was the junction of Wood Street and Route 6N. At the southern end of the valley is Lake Osceola, once known as Round Pond or Jefferson Pond, and a glacial remnant of the last Ice Age.

Primarily agricultural, the valley began to slowly change with the opening of the first post office in 1850. By 1867, there were three blacksmiths, a store, the H. Rankin Hotel and a school. Jefferson Valley's second claim to fame was a tornado that touched down in 1874, lifting a house off its foundation and moving a hay wagon a distance of two miles.

Urban development continued in the 20th century, with the introduction of two infamous saloons and the subsequent Union Chapel, the valley's first.

It was undoubtedly the proliferation of automobiles, however, that catalyzed Jefferson Valley's greatest change. Fleeing from New York City, post–World War II settlers populated the countryside, and commuters replaced farmers who could no longer afford to farm. Many of the old orchards and dairy farms succumbed to bulldozers, housing developments arose, and the new community demanded more schools and improved transportation. In 1957, the Lakeland Central School District built Thomas Jefferson Elementary School. Eight years later, the new Route 6 was constructed, altering Jefferson Valley forever.

The most visible result of these sweeping demographic changes is what some see as the new communal center: the two-level 900,000-square-foot Jefferson Valley Mall. Built in 1983, the mall was renovated in 2002.

—Susan Chitwood

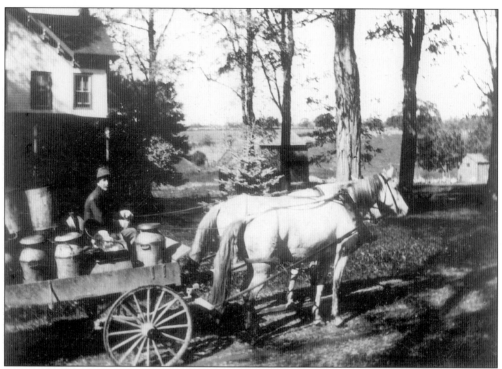

A local farmer, with milk wagon and team, is on his way to deliver milk in October 1919.

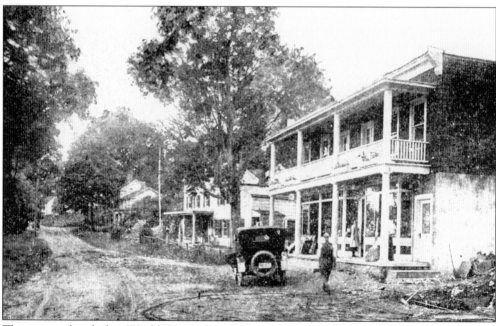

This view, taken before World War I, shows Main Street in Jefferson Valley when it was still a dirt road.

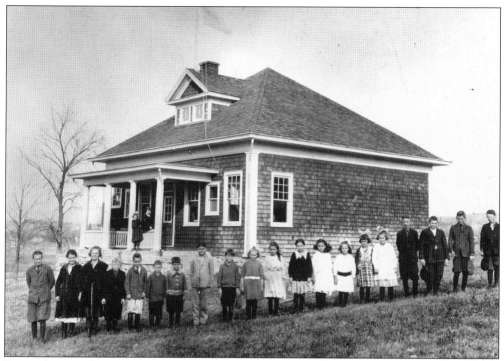

Pictured are students outside the Jefferson Valley School in 1921.

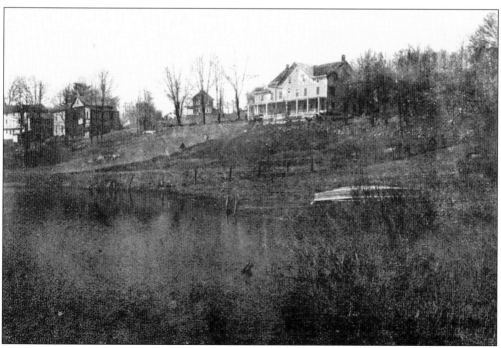

This view of Lake Osceola was taken prior to 1917. In the background is Bailey's Lodge, on East Main Street.

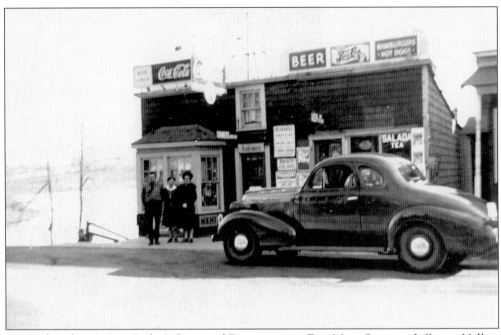

Pictured in the 1940s is Bailey's Store and Restaurant on East Main Street in Jefferson Valley, with Lake Osceola in the background. Although most of the Kitchewanc Indians had disappeared from Jefferson Valley by 1900, storeowner Mrs. Benjamin Bailey recalled their occasional reappearance in the 1920s. Garbed in traditional attire, they would climb Indian Hill, their final home place. After paying their respects to the dead, they would descend and stand on her Main Street property and face east, praying in silence.

Bailey's Lodge (left) is pictured after a snowstorm in 1947. The milk dealer's license (right) was issued to Mrs. Howard Bailey in 1936.

Outside the Weston Barrett Store, in Jefferson Valley, are Walt and Gladys Clearwater (center) and two men.

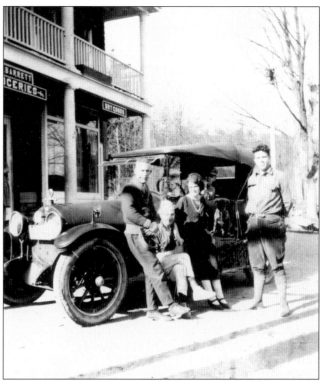

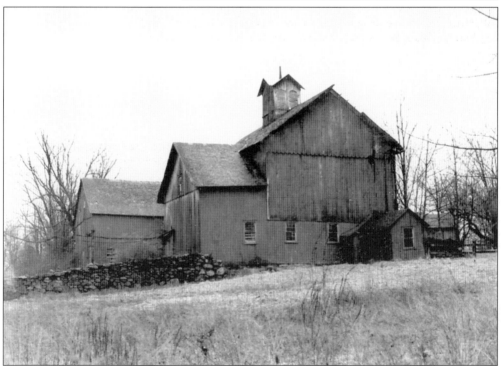

Purchased by Abraham Hill in 1847, this fruit and dairy farm was operated over the years by three generations of the Hill family. (Photograph by Nancy Augustowski.)

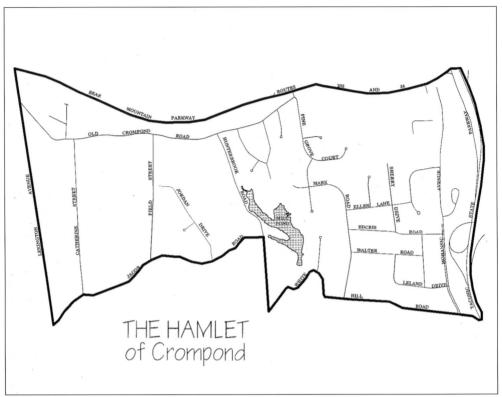

THE HAMLET
of Crompond

This is a map of the hamlet of Crompond. (Prepared by Robyn Prestamo, Yorktown Planning Department, 2003.)

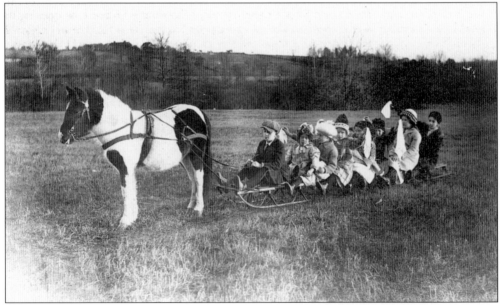

A fully loaded horse-drawn sleigh is pictured on the Melbourne Farm, owned by John Q. Barnes. The farm is the present site of the Yorktown Middle School and High School and the district administrative offices.

Ten
THE HAMLET
OF CROMPOND

Yorktown's early Colonial settlers knew their community as Crompond, a Dutch word that means crooked pond. This part of the Manor of Cortlandt land grant, large tracts of land with far-reaching roads, was extensively farmed. Its rivers, lakes, and brooks provided sufficient waterpower for gristmills and tanneries. During Colonial times, Crompond Road, now Route 202, was called the King's Highway. It was utilized by British and American forces during the Revolutionary War, and the tread of soldiers en route to and from fortifications on either side of the Hudson River was heard many times along the rutted dirt roads through Crompond. Skirmishes and raids occurred during this period at the strategic Croton River crossing at Pines Bridge, the Croton Heights area, and Crompond Corners, three miles north. Located at the corner of present-day Routes 202 and 132, Crompond Corners was the principal area of commerce. It was a small village with a house that was used as a post office and tavern. Its neighbor to the west was the Crompond Presbyterian Church, parsonage, and storehouse, built in 1738.

Directly across the road from the church, tradesmen, taking advantage of a brook that provided water, operated a tannery, slaughterhouse, and gristmill. A blacksmith shop, cobbler shop, and tavern were also part of this small enclave. None of the original buildings (with the exception of the house utilized as the post office and tavern) exist today. The house, now a private residence, still sits across the road from the present-day Presbyterian church and appears to have played an important role in the history of Crompond Corners. The oldest section of the house is the downstairs tavern and a cook room. Another interesting feature is an opening in the fieldstone foundation that appears to be an underground tunnel, now filled in and rumored to have been a passageway from the house to the parsonage across the road. During the Revolutionary War, area patriots met at the church parsonage, which was also used as a barracks for some of Col. Samuel Drake's regiment under the command of Capt. Henry Strang. The Yorktown Committee of Public Safety used the church buildings to assemble, transact business, and store confiscated arms. On June 13, 1779, the British, hearing that the parsonage and adjacent storehouse were being used to store arms, dispatched troops from Verplanck's Point to raid and burn the parsonage and storehouse. The British returned a few weeks later, on June 24, to destroy the church.

A few years after the war, on May 30, 1784, church members passed a resolution to build a new church, which was completed in 1785. Following the war, farmhouses, fences, and stone walls were repaired. Farming activity resumed, and the village of Crompond Corners remained active until the arrival of the railroad in 1881. After that, the center of commerce moved to the railroad depot area, Crompond Corner tradesman relocated, and new mercantile opportunities developed.

—Monica Doherty

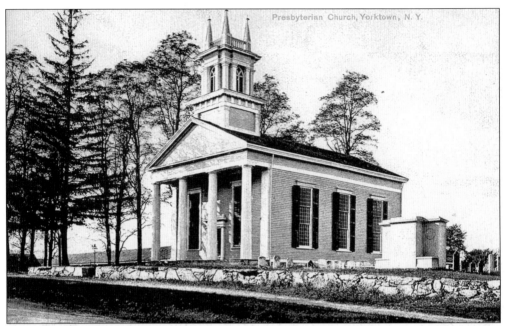

Presbyterian Church, Yorktown, N. Y.

During the Revolutionary War, the church parsonage was the center and rallying place for the patriots. On June 24, 1779, the British troops, during a surprise attack, burned the church to the ground. The church was rebuilt in 1785 and used until the present building took its place in 1840. The land on which it stands was part of the Van Cortlandt Manor, and members of that family attended its services.

This quilt, designed by Yorktown resident Barbara Wilkens, is part of the permanent collection displayed at the Yorktown Presbyterian Church.

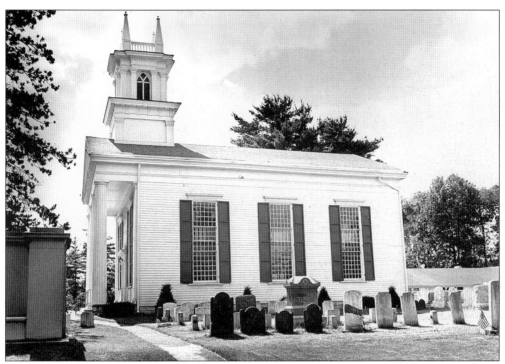

The Yorktown Presbyterian Church, on Crompond Road, is built on the site of two previous church buildings. The first, built in 1738, was burned during the American Revolution. A new church was built in 1785, and that was replaced by the present church in 1840. The cemetery contains many Revolutionary War patriots and early residents.

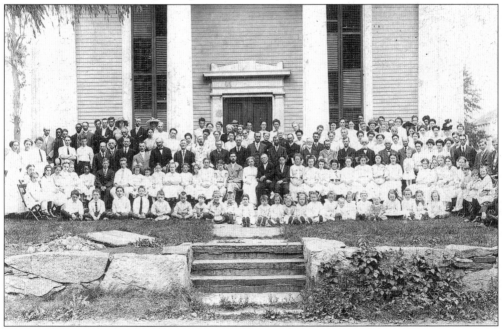

A gathering is held c. 1907 at the First Presbyterian Church in honor of the retirement of the minister, the Reverend Mr. Cummins.

Horse-drawn wagons filled with produce from local farms and orchards were a common sight in the 1930s and 1940s along Old Yorktown and Crompond Roads, today Routes 132 and 202, respectively.

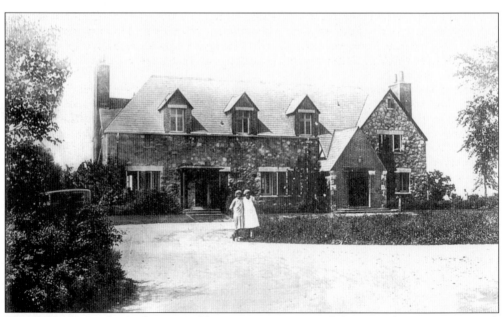

The clubhouse at the Mohansic Golf Course is now part of the Westchester County Park System. (Courtesy of Dolores Pedi.)

Eleven
NEIGHBORHOODS

Yorktown has seven distinct neighborhoods. The seven areas and the contributors who wrote about them are as follows: Amawalk, Adele Hobby; Croton Heights, Nancy Truitt; Crow Hill-Colonial Heights, Monica Doherty; Huntersville, Susan Chitwood; Kitchawan, Sophie Keyes; Sparkle Lake, Alice Roker; and Teatown, Sophie Keyes.

Amawalk lies in the northeast corner of Yorktown. Its post office is located a quarter of a mile east of the town of Somers and 30 miles north of New York City. In 1609, its hills were the site of a Native American village called Amawalk, meaning "the place of the white (birch) tree" or "the high ground on which the birch trees grow."

Croton Heights was part of the original land grant to Stephanus Van Cortlandt from the British Crown. Before the royal seal was affixed to a grant, the land had to be purchased from the Native Americans, who agreed to a price of six shillings in 1683. The grant was not completed until 1690.

The Crow Hill-Colonial Heights neighborhood lies in the southeast section of Yorktown and has a history all its own. Nestled in the valley below Crow Hill, the farming community grew and prospered, mainly because the Croton River provided both waterpower and a waterway to the docks at Van Cortlandt Manor and the Hudson River. Originally called Crotonville, the settlement contained mills, stores, taverns, farmhouses, barns, a church, and a cemetery.

Present-day Huntersville covers six square miles between the Taconic Parkway, Route 129, and the town of Cortlandt border. Of the old neighborhood, little remains other than several homes, a school, and the old church and cemetery at the junction of Baptist Church and Hunterbrook Roads. Most of Huntersville was lost to the waters in the early 1900s, after a mammoth dam was built, flooding 20 square miles in the path of the Croton River.

Kitchawan lies between the Taconic Parkway and Route 100 south of the Croton Reservoir. Although just east of the Teatown area, it is a different neighborhood in many respects. First settled by Native Americans, who cultivated the land and fished the nearby rivers, the property was later sold by the Van Cortlandts to families who, in some cases, retained ownership over several generations.

Sparkle Lake, on Granite Springs Road, was once known as Hyatt Pond and was the local watering hole for cattle. As the Civil War got under way in 1861, Major Hyatt purchased 162 acres of farmland in the northeast section of Yorktown. The farm remained in the hands of the Hyatt family until in 1926, when it was sold for $19,000. The new owner, Frederick Merk, transformed the farm into a thriving summer colony, which later became a year-round subdivision.

The fertile, wooded landscape of Teatown, with its stream, ponds, and low hills, drew settlers from the earliest times. Native Americans of the Kitchewancs, Dutch landowners of the Van Cortlandt family, tenant farmers who eventually became farm owners, and modern residents escaping the growing population of New York City came to this area.

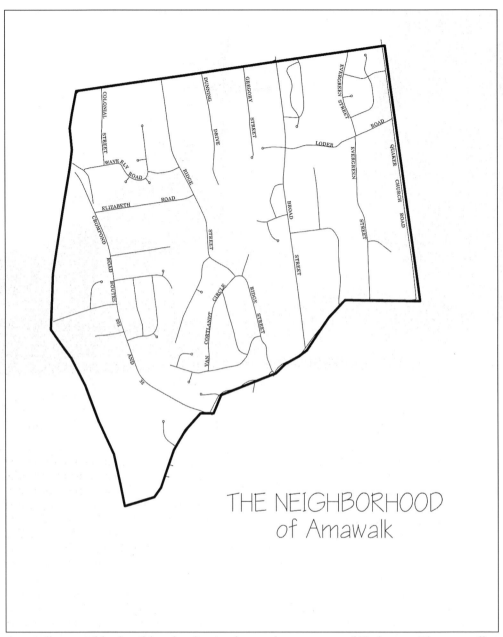

THE NEIGHBORHOOD
of Amawalk

Amawalk, a neighborhood hamlet, lies in the northeast corner of Yorktown. The post office bearing the name Amawalk is located a quarter of a mile east in the Westchester town of Somers and 30 miles north of New York City. The Native Americans called these hills Amawalk, "the place of the white (birch) tree" or "the high ground on which the birch trees grow." Birches flourished here and were an integral part of the lives of Native Americans, providing the bark needed to fashion their canoes. The name is a contraction of the Native American word "Appamaghpogh" and "Amawogh." Game abounded in these forests, and fish were plentiful in the numerous streams. The smaller brooks are still visited today by enthusiastic anglers. Shown is a map of the neighborhood of Amawalk. (Prepared by Robyn Prestamo, Yorktown Planning Department, 2003.)

Amawalk Nursery was located primarily in the town of Yorktown. In its prime, it was the largest single piece of business property in Westchester County, with 1,068 acres. Yorktown owes much of its beauty to the fact that Amawalk Nursery once covered many acres, with trees including pine, spruce, and beech. It was the biggest big-tree nursery in the world, selling "adolescent" rather than baby trees. The trees it sold were between 6 and 18 years old. Some two million trees were growing at the nursery in 1928, and 250,000 were sold that year. The nursery's high standards led it to be called the Tiffany's of the nursery business. Shown is one of the large trees from the nursery being transported to the Amawalk Railroad Station. The station was the embarkation point of most of the trees headed to the far reaches of the country and the world. The trees were carried to the station first by horse and mule teams and later by truck. Located on the corner of Quaker Church Road and Routes 202/35 (Saw Mill River Road), the station included the post office and telegraph office. Part of the former old Putnam Railroad property, it is used today as a small parking area for the North County Trailway.

Maj. Orlando Jay Smith was an accomplished man. He was the founder of the Associated Press, a Civil War veteran, a friend of Ralph Waldo Emerson, and the author of two books. In 1904, he purchased from Andrew Travis a home and 249 acres west of the Amawalk Railroad Station. He started a tree farm as a hobby and spent years cultivating and tending his trees. He experimented with seedlings and imported rare specimens from England, Holland, and France, without ever selling a single tree. After Smith died in 1908, his son and two daughters inherited the 249-acre farm. His son, Frank Smith, turned to the newspaper business; his daughters, Evelyn W. Smith and M.F. Smith, managed the tree farm. In 1919, Evelyn Smith (above) became president of the tree farm when she purchased her sister's shares. Partly from sentiment and partly from necessity, she turned the farm into a nursery, in which top-notch trees continued to grow as a living tribute to her father. The nursery grew to more than 1,000 acres, as she continued to purchase neighboring farms, including the Post-Ferris Farm on Saw Mill River Road, property that once served as barracks for 100 Italian laborers who worked at the nursery. She sent many large trees as gifts to dignitaries and heads of state. She also supplied the White House with its first living Christmas tree, a Norway spruce planted in 1924 during the Calvin Coolidge administration. That tree was used until 1934. She also sent trees to the 1939 New York's World Fair and to the Tomb of the Unknown Soldier. Although the majority of the million-plus trees were grown in Yorktown, Amawalk received the notoriety.

John Degbrenner paused with two mules while cultivating barberry bushes on the Amawalk Nursery grounds. He wore nursery badge No. 83 (below). Among the properties Evelyn Smith later purchased were the historic Hallock's Mill Pond, where nurserymen cut ice for many winters and where, today, local boys and girls swim, fish, and ice-skate; the David Irish property, on the corner of Broad Street and Saw Mill River Road, where a barn was later converted into a tavern and antiques gallery, which operated for many years; the Flewellen property, in 1927, across the brook from the Irish farm; the Seth Whitney farm, later known as Dr. Scholderfer's home and office, on Route 202; the home of Elijah Lee, on Granite Springs Road, today, Guiding Eyes for the Blind School; and the Anson Lee farm, on Old Crompond Road, now known as Old Granite Springs Road. In 1932, Amawalk Nursery closed its doors following two tragic fires, overly rapid expansion, and the devastating effects of the Depression. The business filed for bankruptcy and, in 1943, was purchased by a syndicate of New York City businessmen called the Amawalk Holding Corporation. General manager Clarence Murphy continued the nursery operation until the property was sold outright. Part of the former Irish property, across the brook, and the former Flewellen property were developed into the Amawalk Golf Course, a nine-hole public course on Broad Street next to where the Brookside School stands today. (Badge courtesy of Dorothy Anderson, John Degbrenner's daughter.)

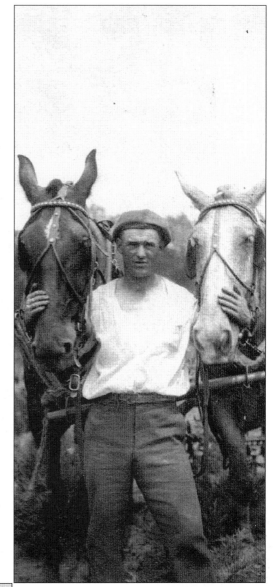

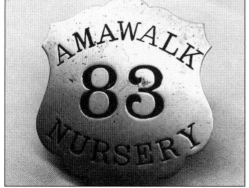

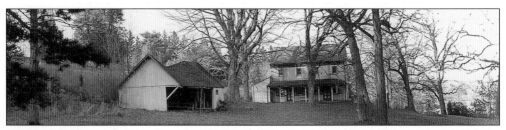

Property that once belonged to the Amawalk Nursery and its beautiful trees surround the Amawalk Friends Meeting House and a Revolutionary War cemetery, called the Friends Burial Ground. Both are located on Quaker Church Road in Yorktown Heights. The current meetinghouse was built in 1831 and still has active members. The building, the third on this site, holds more than 150 people, reflecting the large membership it had in the early 19th century. Important issues for Quakers were support of education and opposition to slavery and war. A porch was added c. 1860. Today, the building has no electricity, is heated in winter by two wood-burning stoves, and has no plumbing. The property occupies 2.9 acres including the cemetery. The first building on the site was constructed in 1773, and the second was built in 1785. Records are unclear as to how the first building was destroyed in 1779 during the American Revolution. The second building burned down on December 14, 1830. Early Amawalk Quakers "shared fellowship" with the local Native Americans. In the early 19th century, attendance at Sunday service was often over 200 people. Today, fewer than 20 people attend. Amawalk remains among the smallest of Westchester's six Quaker meetinghouses. The building was listed on the National Register of Historic Places in 1989. It was one of the first 10 historic landmarks in Westchester County. In 1987, a nursery school was built on the property.

Hallock's Mills was a Revolutionary War industrial center in what was to become Yorktown Heights. Between 1728 and 1778, the center was comprised of a gristmill, a sawmill, a blacksmith shop, a wheelwright shop, and a shoemaker shop. Grain was ground into flour for Washington's troops, and cannonballs, bullets, and cannons were made and repaired for the Continental army. The original milldam of stone was kept in repair by David J. Irish, a direct descendant of Richard Hallock. Later, the Hallock house included the Hallock's Mills Post Office and a private school. Only some of the original stone foundations remain, and they are located on private property in a residential area just north of the town's current business district. This property later became part of the Amawalk Nursery. It is bounded on the east by Ridge Street, on the west by Broad Street, on the south by Saw Mill River Road, and on the north by the Old King's Highway (Route 202) and the millpond. By 1838, Hallock's grist and sawmill was one of six in the town of Yorktown. The Hallock's Mills complex was significant in the economic and social development of the area. It was also part of an important commercial system that helped to develop New York City into a leading port in the world. Stone foundations are all that remain of Hallock's Mills. The remaining stones provide above-ground evidence of the milling industry in Yorktown. Today, there are no millers in Yorktown. This painting is of Hallock's Mills in 1956.

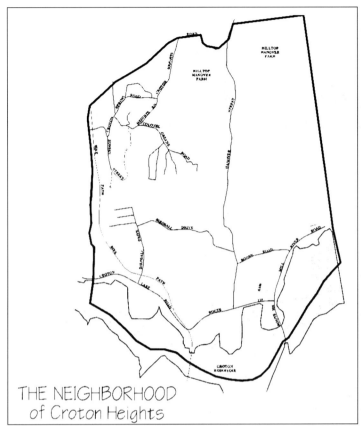

THE NEIGHBORHOOD
of Croton Heights

Croton Heights was part of the original land grant to Stephanus Van Cortlandt from the British Crown of William and Mary. Before the royal seal was affixed to a grant, the land had to be purchased from the Native Americans, who agreed to a price of six shillings in 1683. The grant, however, was not completed until 1690. Almost 80 years later, in 1769, the Croton Heights area was sold to Zadoc Birdsall. The Davenport House (across from the present Peter Pratt's Inn) was built in 1750 and rebuilt in 1776. The road it faced was called Cross Road and, later, at least in part, Davenport Road. It is now called Croton Heights Road. The Croton River could be seen from the Davenport home. During the Revolutionary War, in early 1781, the British were in possession of New York City. The American lines ended at the Croton River. Pines Bridge was in use, and there were protective earthworks on Crow Hill, near the village of Crotonville. Two fords also provided river crossings. An advance force for the Continental army, including Col. Christopher Greene and 28 officers and men, was posted at the Davenport House, headquarters for surveillance of the Croton River. In May 1781, the British marched north, reaching the Croton River in the early hours of May 14. They forded the river and moved north on the east side of Turkey Mountain, approximately where Route 118 runs today. With a force of 200 soldiers and 100 mounted troops, the British approached Croton Heights. Led by Col. James Delancy, the troops marched toward the Davenport House, intent on capturing Greene in retaliation for a previous attack on Delancy's quarters. They surprised the sentry, who fired and fled into the house. In the ensuing battle, many troops of the 1st Rhode Island Regiment were killed and Greene and Maj. Ebenezer Flagg were mortally wounded. As the British attempted to take him away on a horse, Greene fell off into a whortleberry patch and was left to die alone on what was known a Pig Lane. Some 143 years later, the road was renamed Colonel Greene Road in his honor. Above is a map of the neighborhood of Croton Heights. (Prepared by Robyn Prestamo, Yorktown Planning Department, 2003.)

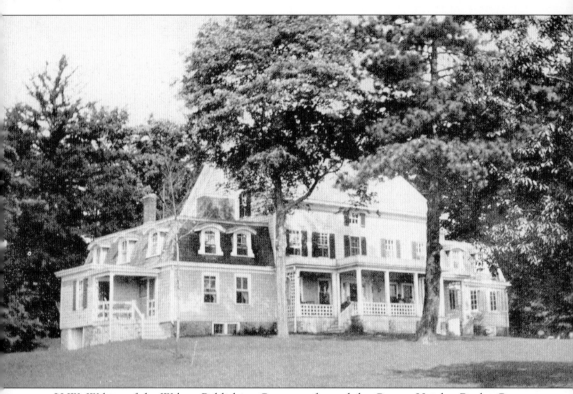

H.W. Wilson of the Wilson Publishing Company formed the Croton Heights Realty Company in the 1920s. Residential development began, as house lots were sold to friends and employees who were city dwellers and wanted summer homes in the country. Wilson operated the Pratt's Inn as a boardinghouse for the convenience of lot purchasers who were building their cottages. In James Fenimore Cooper's story "The Spy," the central character spies for Gen. George Washington in this area and speaks of the "heights of the Croton." It may be that Wilson, a renowned New York publisher, chose the name from Cooper's work. The first cottage builders spent their weekends clearing brush and supervising construction. They got off the Putnam line train at Croton Lake and hiked two miles uphill, packs on their backs, to the inn. Along the way, they passed Mary Birdsall's farm, where they would stop for eggs and milk, adding those to their load. When they arrived at the inn, a special dinner provided by innkeeper Mrs. Wilson always awaited them. Wilson built the first Croton Heights railway station on the Old Put line in 1930. The station was a three-sided structure, with benches and a flag to wave madly about to get the train to stop. The New York Central later replaced the structure with a real station. The Croton Heights Association built a road to the station in 1946. Shown above is Peter Pratt's Inn, formerly Croton Heights Inn. The inn was part of the Carpenter-Davenport homestead, which encompassed 250 acres. The restaurant part of the inn was originally the foundation of a barn built in 1760. The dining room remains authentic in its Colonial design and construction. Across the street from the inn is the Davenport House, which served as the North Continental army command post during the Revolutionary War.

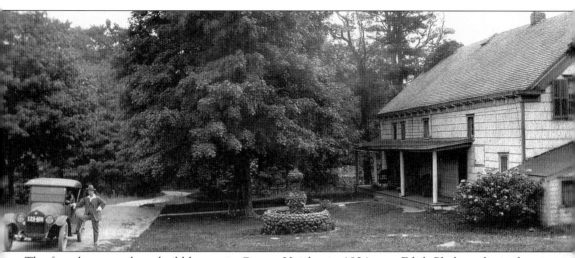

The first three people to build homes in Croton Heights in 1924 were Edith Phelps, editor of the Wilson Handbook series; Gladys Russell, secretary to the president of the Rockefeller Foundation; and Eleanor Duncan, editor of the *Library Journal*, who was later joined by architect Betty Coit, designer of some of the homes built in Croton Heights. By late 1924, "eight hardy souls had settled in Croton Heights. Notice the gender of these first 'pioneers.' In fact, the community's name for the area at the end of Colonel Greene Road that was settled by women was 'No Man's Land.' " On July 3, 1926, the first dinner was served at the newly named Croton Heights Inn. In attendance were 39 members of the community and 15 guests of the inn. A special room rate accompanied the opening: $25 per week, American plan. Dinner cost either 85¢ for fresh fruit cup and soup and use of a paper napkin, or $1 for both fresh fruit cup and soup and use of a linen napkin. By 1942, prices had risen to $1 for breakfast, $1.25 for lunch, and $1.75 for dinner. Each spring, Mrs. Wilson reopened the inn with a dinner invitation to all the residents. Each Christmas, the Wilsons presented the children of the area with gifts of books or candy. A slogan from a 1926 Croton Heights Realty brochure read, "A thousand dollar investment in Croton Heights now insures present happiness and future income." Acre lots sold for between $500 and $1,200. By 1935, there were 29 homes in Croton Heights. Piped water came to central Croton Heights in 1926. First installed by the developer, the water system was later improved and expanded by the town. Some 67 years later, several homes still were getting water from wells. In late 1934, a stonemason named Chester Tompkins was contracted by Wilson to build a stone wall to distinguish the entrance to Croton Heights. Tompkins designed the wall out of granite blocks ordered from the quarry in Mohegan. The blocks formed two pillars that were carved by Tompkins with the name of Croton Heights on them. Tompkins hired his brother, Wally Tompkins, and Jim Wilson to work with him. The heavy blocks were laboriously brought up from the stream area below the road. Because he was so busy during the other times of the year, Tompkins had to undertake the building in the winter. This meant difficulty mixing the mortar and getting it to set properly. Tompkins and the other masons kept a fire going and mixed the mortar with hot water. They also added a type of special salt to the mortar to help the setting process. Tompkins used a particular technique in constructing the walls in order to show off the size, shape, and color of the stones. The mortar was not brought out to the face of the stones but, rather, set in. The wall took several months to complete. Stone walls and paths were built throughout the Croton Heights area, including a path up from the train station, which included a series of descending pools. Sadly, most of the walls have been destroyed over the years; those at the entrance to Croton Heights stand as the only reminder of the stonework that once graced the area. Recently, the entrance received historic landmark status from the town of Yorktown. Above is the Charelen Farm in Croton Heights.

In early times, as now, "fire was an ever present hazard." H.W. Wilson installed a fire gong with a hammer, pails, and brooms in a shed across from the Croton Heights Inn. There was a code to ring the area location of the fire so everyone knew where help was needed. The gong is now installed between the Yorktown Heights fire station and Mitchell's Hardware. The Croton Heights Community Association was formed in 1942. A total of 45 people attended the first meeting. Spraying the roadside for poison ivy was the first community project. Until 1956, the roads in the area were cleaned and maintained by the association. In winter, the plowing of roads was not only a necessity for the year-round residents but also a social event. Volunteers sat on a large wooden wedge that was filled with rocks and pulled by a tractor. When the snow was too deep, additional bodies were recruited to weigh down the plow. The association continues to be active, representing the area's interest in town affairs, obtaining benefits for residents through such efforts as the oil cooperative, and bringing neighbors together for annual events such as the holiday dinner celebrated at the inn. Hilltop Hanover Farm (above) is located between Hanover and Croton Heights Roads. A major dairy and cattle-breeding operation, it is now earmarked for farmland and open space preservation. (Croton Heights information from materials prepared by residents over the years and from "The Early Days," by Charlie Doolittle, the *Croton Heights Cookbook,* published is 1993, republished in 2003, by the Croton Heights Community Association.)

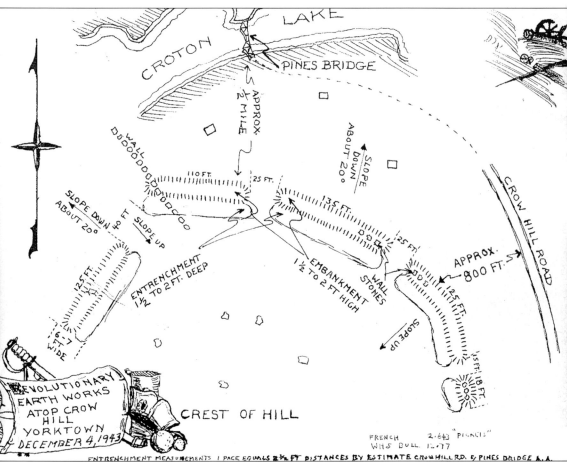

CROTON LAKE

PINES BRIDGE

APPROX. ½ MILE

WALL

110 FT.

25 FT.

ABOUT 20°

SLOPE DOWN 20°

SLOPE DOWN 40 FT ABOUT 20°

SLOPE UP

135 FT.

25 FT.

25 FT.

EMBANKMENT 1½ TO 2 FT. HIGH

WALL STONES

APPROX. 800 FT.

CROW HILL ROAD

125 FT.

ENTRENCHMENT 1½ TO 2 FT. DEEP

25 FT.

18 FT.

SLOPE UP

SLOPE UP

6-7 FT. WIDE

CREST OF HILL

REVOLUTIONARY EARTH WORKS ATOP CROW HILL YORKTOWN DECEMBER 4, 1943

FRENCH 2,643 "PICKETS"
WHS BULL. 12-77

ENTRENCHMENT MEASUREMENTS 1 PACE EQUALS 2¾ FT DISTANCES BY ESTIMATE CROW HILL RD. & PINES BRIDGE A.A.

Crow Hill-Colonial Heights, the southeast section of Yorktown, has its own unique history. Families purchased land from the Van Cortlandts, settled along the banks of the Croton River, and practiced farming. The river provided not only waterpower for the grist and fulling mills along its shores but also a waterway to the docks at Van Cortlandt Manor and the Hudson River. Nestled in the valley below Crow Hill, the farmers cleared the land and built stone walls. They also built small bridges to span the river to reach the roads that took them north to Crompond Corners and Peekskill. The settlement, called Crotonville, contained mills, stores, taverns, farmhouses, barns, a church, and a cemetery. Early records note that one of the earliest bridges was built in 1769 by John and Jay Pine, who charged a fee for its use. Called Pines Bridge, it was used for many years as it was the only way to cross the Croton River, other than a shallow ford to the west. In 1791, the townships of Stephentown (Somers) and New Castle assumed management of the bridge. All was peaceful within this frontier community until the advent of the Revolutionary War. Following the Battle of White Plains, on October 23, 1776, Gen. George Washington ordered Gen. Reazin Beall and his Maryland regiments to construct fortifications atop Crow Hill Road to protect the Croton Valley and to guard the critical Pines Bridge crossing below. All that remains today are faint outlines of the earthen work trenches that helped secure Pines Bridge. The above diagram shows the trench works near the crest of Crow Hill. From this spot, American troops could command all approaches to Pines Bridge and the Croton River Valley. These trenches are located on private property and are not accessible to the public.

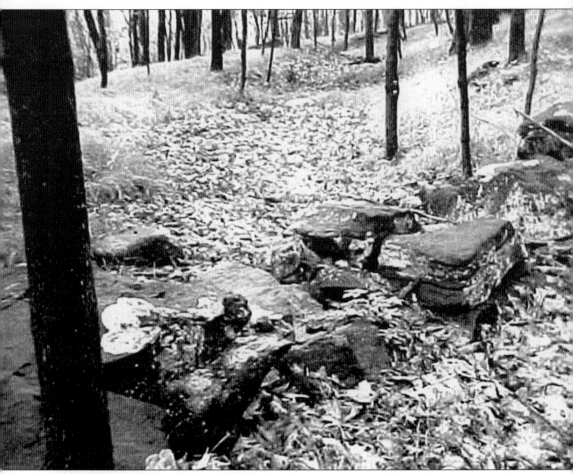

Languishing silently atop Crow Hill are the faint depressions of the earthen trenches that were built following the Battle of White Plains on October 23, 1776. They were constructed by Gen. Reazin Beali and his Maryland regiments to protect the Croton River Valley and the critical Pines Bridge crossing below. The Totten family, who owned the farmland, had to leave as soldiers overran the farm and destroyed fences and crops. Pines Bridge and adjoining roads were used extensively during the Revolutionary War by American soldiers and General Rochambeau's French regiments. The next disruption the residents of Crotonville endured occurred when the Croton River was dammed to provide drinking water for New York City. The building of the first Croton Dam and Croton Aqueduct began in 1837 and again in 1892, when the new Croton Dam was built. The dam flooded the village of Crotonville. Some buildings were dismantled, and others, such as the Pines Bridge Inn, were moved to higher ground. Many of the farming families moved to other communities. (Courtesy of Harry M. Dunkak, CFC, Ph.D.)

The Birdsall family of Yorktown dates back to the 18th century. Zadock Birdsall was granted 200 acres of land by King George III in 1769. In the late 1800s, the land was divided equally and given to Jonathan and Daniel Birdsall. The land changed hands again in the early 1900s, when it was given to Amy Griffin, niece of Daniel Birdsall. David Birdsall, born on January 1, 1933, was the first in his family to be born in a hospital. He recalls: "Life was very simple. There were about twenty-five hundred people in the entire town and Commerce Street was the only street. We had a General Store where Friendly's sits today. Douglas Dunning, the owner of the local garage was also the school bus driver." His Aunt Maye had a lawn-mowing business, paying the local youngsters 25¢ an hour. His father, Edward Birdsall Jr., spent many years tending to his animals, crops, and apple orchards. Birdsall liked to hear stories from his father, who was born in Yorktown in 1899. "Yorktown has less than fifteen hundred people until laborers working on the Croton Dam came to town and set up a tent city. There were stories of stabbings, and a strike by the European laborers who worked on the dam. The violence ended after Teddy Roosevelt sent in his troops." One day while driving his father's Model T, David Birdsall tried to evade Police Chief Hawks and wound up in a ditch. The c. 1905 scene above shows cattle crossing the road—a common sight in Yorktown during earlier days. (Courtesy of the Lee collection.)

THE NEIGHBORHOOD
of Crow Hill
Colonial Heights

In 1905, a new bridge was built across the Croton River to replace a series of antiquated wooden structures. The abutments of the original Pines Bridge are now under water. The advent of the railroad in 1881 also played an important part in the history of this section of Kitchawan. The area that was once a farming community took on a different look. Elegant hotels with cupolas and wraparound porches were built on the hillside overlooking Pines Bridge and the newly created Croton Lake. The Pines Bridge Inn and the Colonial Hotel on Crow Hill Road lured New York City residents during the summer. With its walking and hiking paths, golf course, and sparkling mountain spring water, the area became an ideal summer getaway for city dwellers. As time passed, the once grand hotels were destroyed by fire and decay. Homes now dot the hillside where history and seasonal vistas are still enjoyed. In 1987, the 1905 bridge was replaced by a 700-foot concrete span. Above is a view of the river from the western veranda of the Colonial Hotel on Croton Lake. On the left is a map of the neighborhood of Crow Hill and Colonial Heights. (Prepared by Robyn Prestamo, Yorktown Planning Department, 2003.)

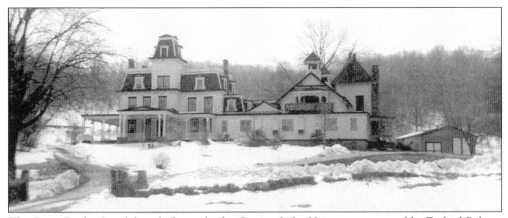

The Pines Bridge Inn (above), formerly the Croton Lake House, was erected by Ezekial Palmer in 1868. An addition was built in 1879, and the building was moved from the village of Crotonville to its present site prior to the completion of the New Croton Dam in 1907. The three-story wood-frame structure, with accommodations for 40 guests, was one of the larger hotels built below the summit of Crow Hill. It accommodated guests from New York City, who came to enjoy the fresh air and splendid vistas. During the late 1800s, it hosted local political conventions, and during Prohibition, it became a favorite speakeasy. In later years, the inn functioned as a restaurant called Frank Longo's Pines Bridge Lodge. In December 1975, the 107-year-old landmark was destroyed by fire, with arson as a possible cause; nine empty containers, some of which were marked "gasoline," were found in a garage on the property. No charges were ever filed. The Colonial Hotel (below) was built in the late 1800s high on a hill overlooking Croton Lake. A summer resort for people from New York City and the surrounding area, it could accommodate 150 guests. The 175-acre property included golf links and tennis courts, as well as many trails for hiking and riding. The hotel offered bowling and croquet, a library, and a music room. Stables were available for guests to board their horses, and carriage rides could be arranged. A tower was erected at the summit of Colonial Heights with platform steps and seats for guests who wished to enjoy the picturesque views.

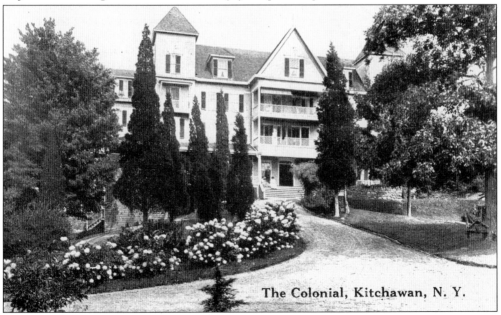

The Colonial, Kitchawan, N. Y.

Colonial Split Rock Spring, Kitchawan, N. Y.

Guests enjoy the porch of the Colonial Hotel. Only "sparkling mountain spring water" from the Colonial Split Rock Spring (left), on the hotel grounds, was used in the Colonial's dining room. Recommended by some of the best physicians in the state, the water was also bottled and shipped to customers in New York City. (Above, courtesy of 1907 Colonial Hotel brochure; left, courtesy of Dolores Pedi.)

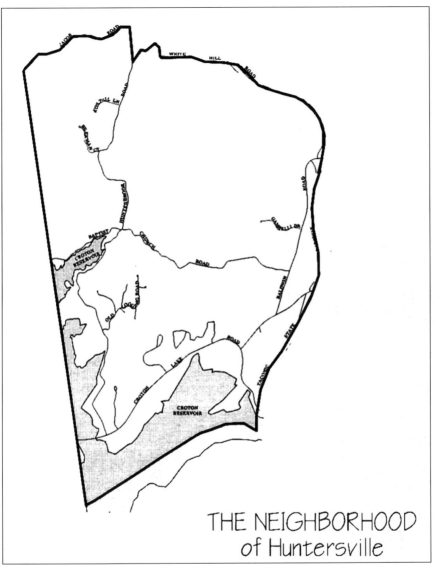

THE NEIGHBORHOOD
of Huntersville

Present-day Huntersville occupies six square miles between the Taconic Parkway, Route 129, and the town of Cortlandt border. Most of the old Huntersville was lost after the new dam project flooded some 20 square miles in the path of the Croton River. Of the old hamlet, little remains intact other than several homes, a school, and the old church and cemetery at the junction of Baptist Church and Hunterbrook Roads. The stone ruins of a former gristmill are said to stand near the church, but the old Wire Mill or Dugway covered bridge spanning the Croton River was long ago dismantled, burned, and replaced by the Hunterbrook Bridge. Some speculate that a brickyard once existed here as well. The Aqueduct Commission spent 15 years in preparation for the dam: appraising and condemning properties, evicting occupants, and relocating hundreds of buried bodies. Families moved to Route 129 or Yorktown. Built in 1907, the dam brought Irish and Italian immigrants to the area and took years to complete. The above map shows the neighborhood of Huntersville. (Prepared by Robyn Prestamo, Yorktown Planning Department, 2003.)

Shown is the Florenceville School, located on Hunterbrook Road in the 1880s. Whether the ghostly underwater ruins of old Huntersville still exist is hard to say. There is a chance that something is still there. In 1957, half a century after the New Croton Dam was built, area resident Sam Tompkins saw his old house when the reservoir was drained for repairs. He also found a pair of children's shoes. Before the waters overran the community, one Tompkins house was saved, dismantled, and rebuilt. It now stands behind Tompkins garage on Route 129. The Department of Environmental Protection headquarters, an old white clapboard home, was allegedly moved on logs. The Tompkins family was among the earliest to settle in Huntersville. Family members may have been tenant farmers before they purchased land in the fertile Croton Valley from the Van Cortlandts c. 1750. Within 70 years, they had amassed 1,500 acres of land. In 1841, a calamitous flood silted the Croton River in, denying farmers access to the Hudson River boats that once transported their goods to market.

Mary Rossiter was a young mother of four when she moved to the new development on Susan Court in 1957. "The day we arrived in Yorktown, our neighbors greeted us with food, cakes and cookies. . . . I did a lot of walking because I didn't know how to drive." With two carriages (one for the doll) and four children in tow, she walked two miles along Route 202 to Downing Park so that the children could run and play ball. Each spring, Murphy's Pond was stocked with trout, and "the children would fish for hours," she recalls. The above scene shows other children of an earlier era fishing in Huntersville, an area known for its bucolic and pastoral beauty.

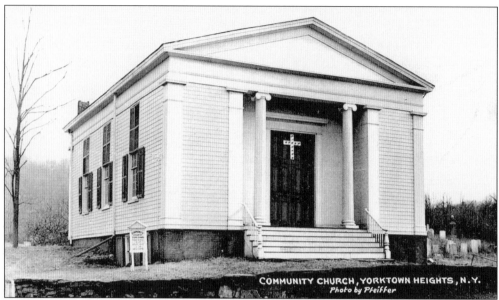

COMMUNITY CHURCH, YORKTOWN HEIGHTS, N.Y.
Photo by Pfeiffer

Although the building of the dam sounded the commercial death knell for the small community of Huntersville, its current residents retain a fierce loyalty to the area they call home. The Huntersville Association, which has had as many as 150 members, works hard to preserve the area. The best-known landmark is the old Baptist church, dating back to the American Revolution, one of the oldest standing churches in Yorktown. Built in 1785 and reconstructed in 1848, the church has been restored and is now the interdenominational Community Church of Yorktown. The adjoining cemetery is where Tompkins family members and pre-Revolutionary residents lie. The nearby parsonage was built in 1802.

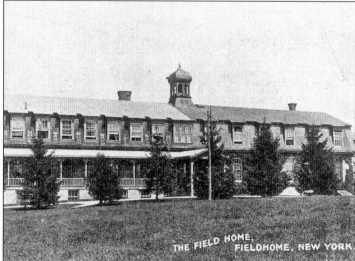

THE FIELD HOME, FIELDHOME, NEW YORK.

On the left is a gas pump at the Wilkens Fruit and Fir Farm, located on White Hill Road at the edge of Huntersville. It is one of the last working farms in Westchester County. On the right is the Field Home, which was founded in 1887 by Cortlandt dePeyster Field in memory of his mother, Catherine. It was set up as place where elderly women who had been secretaries and the like could retire to in their most senior years. It evolved into a retirement and nursing care facility for men and women. (Adapted from Field Home materials.)

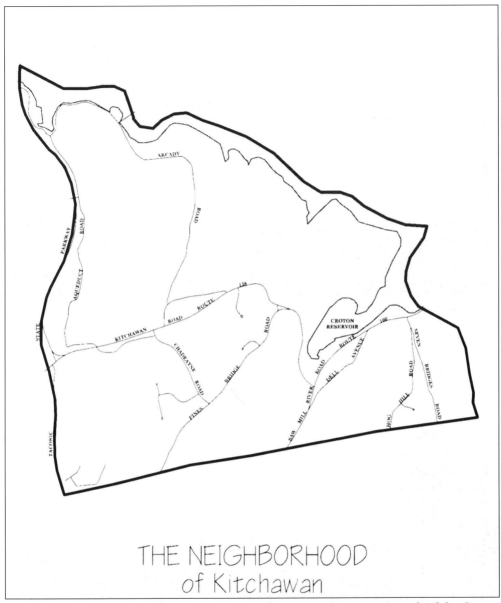

THE NEIGHBORHOOD
of Kitchawan

Kitchawan covers the area between the Taconic Parkway and Route 100 south of the Croton Reservoir, known earlier as the Croton River. Although just east of the Teatown area, it is a different neighborhood in many respects. Native Americans settled here, cultivated the land, and fished in the nearby rivers. Further settlement came later when the Van Cortlandts sold off tracts of their estate to families who, in some cases, retained ownership over several generations. The following are the town's original 18 families as documented in the town archives: Purdy, Flewellen, Forman, Totter, Palmer, Strang, Tompkins, Lee, Cornell, Whitney, Chadeayne, Underhill, Birdsall, Hyatt, Travis, Ferris, Hughson, and White. Several of these families lived in the Kitchawan area.

One of the oldest families was that of Jacob Forman, who migrated from Oyster Bay to Yorktown in 1730 and became one of the town's original 18 families. The Forman farm, originally called Hillcrest Farm, covered 45 acres. After remaining in the Forman family for 250 years, the property was sold in 1979. A few years later, when it again changed hands, the new owners realized they had ties to the Forman family. The Forman house, built in 1734, saw history go by when the British soldiers passed along Old Kitchawan Road. Much later, the house became the location of the first telephone switchboard for the area, with a single operator coming daily.

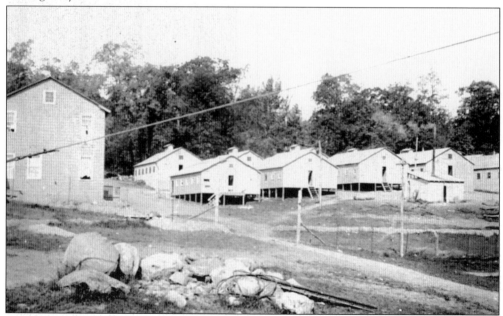

The Forman farm was renowned for its orchards. It employed a large number of local farm hands. Shown is the housing for the workers who were employed at the farm.

In 1759, the Chadeayne family, French Huguenot refugees arriving in America in 1682, bought land and built a house on Pinesbridge Road. The family bought the house from William Skinner, son-in-law of Stephanus Van Cortlandt. The original purchase was 300 acres of land devoted primarily to dairy farming. The house remained in the family for more than 200 years. During the Revolutionary War, there was an encampment of Gen. George Washington's soldiers nearby, with a patrol to guard the Croton River. The soldiers made use of the home, but there is no evidence that Washington ever stayed in the house, which, today, retains many of its original architectural features both inside and out.

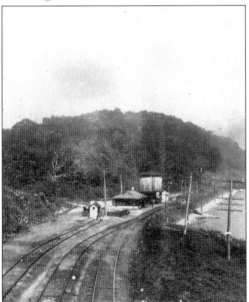
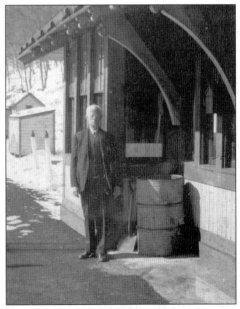

The Kitchawan Train Station was on the edge of Croton Lake. Stationmaster Harry Warner stands in front of the station, which also served as the local post office. According to Bobbie Cochran, Warner used to walk up the hill overlooking the train station to get drinking water from a pure spring that flowed from the hillside.

Workmen are shown haying and apple picking on the Van Brunt Farm in 1940. The first Van Brunts arrived in Brooklyn before 1698. Jeremiah R. Van Brunt, who lived in Brooklyn with his family, purchased the Kitchawan property c. 1912 as a summer home from Col. Joel Erhardt (a Civil War veteran, then provost marshal of lower Manhattan, and later New York City's first police commissioner; some retired police horses lived out their old age on the Kitchawan property). When the Van Brunts were not there, the Kitchawan property was tended by a farmer who sent its produce to them. During World War I, the Van Brunts entertained officers of a U.S. cavalry division sent to guard the Croton Aqueduct. The officers came to the farm, played croquet and tennis, and went horseback riding with the family's four teenage daughters. Major Miller, the head of the outfit, gave his best military horse, Bimble, to daughter Mary Van Brunt. In those years, the 200 acres that today are the Kitchawan Preserve belonged to Fernando Woods, mayor of New York City, and included a beautiful home in back of the Van Brunt house, overlooking the Croton Reservoir. Jeremiah Van Brunt later bought the Woods property, and in the 1940s, he and his family moved to Kitchawan permanently. He commuted into Manhattan on the Putnam Railroad from the Kitchawan station. Later, he sold the Woods house for a nominal fee to the Brooklyn Botanic Garden as a field station for research (where the yellow Magnolia Elizabeth was developed). After he died, his eldest daughter, Elizabeth, let the Brooklyn Botanic Garden acquire the Van Brunt property. In the 1980s, the Woods house was demolished, and the Brooklyn Botanic Garden sold the property to Westchester County. The laboratory is now owned by Warren Institute, a medical research group. (Courtesy of Bobbie Cochran, wife of George Van Brunt Cochran—grandson of Jeremiah Van Brunt and son of Mary Van Brunt Cochran.)

An auto race (left) is held in Kitchawan in 1908. The race was part of the larger Briarcliff, Mount Kisco, and Armonk circuit. Croton Lake hotels and inns were thriving resort destinations until the flooding of Croton Lake. The creation of the Croton Dam and Reservoir brought an end to much of the recreational and tourist traffic of earlier years. At the time of the construction of the Route 134 exit on the Taconic Parkway, the popular Kitchawan Tavern (right) was moved from the parkway to the corner of Chadeayne and Kitchawan Roads. Owned by Duane Nelson, the tavern was known for its food and delightful atmosphere and was advertised as "45 minutes from Broadway." It was eventually sold to the Community Bible Church. Other religious establishments along the eastern end of Kitchawan Road include a Maryknoll home retreat, a Latter-day Saints church, and a Jehovah Witnesses Kingdom Hall. Progress has been kind to Kitchawan, which remains full of natural beauty while supporting more traffic, noise, and development. (Courtesy of the Community Bible Church.)

The building of key roadways such as the Taconic Parkway and Route 100 allowed for a faster north–south trip, which in turn led to more homebuilding and commerce in the 1900s. The Thomas J. Watson Research Center, the headquarters of IBM's research division, was built on Kitchawan Road (Route 134) in 1960 and dedicated in 1961. Designed by Finnish architect Eero Saarinen, the modern building set a new tone for the architecture of the area yet preserved a natural, country-suburban look. The single-arc building (crescent shaped) conforms to the lines of the landscape of its 250-acre site. The site combined the lands from the former Flewellen house (built in 1900) and the Bernen house (built in 1872) on land originally farmed by Henry Purdy. The IBM facility led to the construction of a new exit, at Route 134, from the Taconic Parkway. In the process of excavating the area, the workmen uncovered bones from a woolly mammoth, which can be seen today at the New York State Museum in Albany.

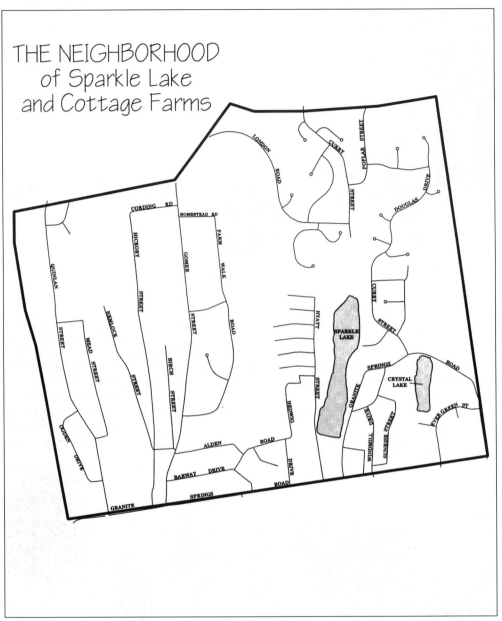

THE NEIGHBORHOOD
of Sparkle Lake
and Cottage Farms

What we now call Sparkle Lake, on Granite Springs Road, was once known as Hyatt Pond. It was the local watering hole for cattle. As the Civil War got under way in 1861, Major Hyatt purchased 162 acres of farmland in the northeast section of Yorktown. The farm remained in the hands of the Hyatt family until it was sold in 1926 for $19,000. The new owner was Frederick Merk (a New York City printer for Outlook Magazine), who transformed the farm first into a thriving summer colony and later into a year-round subdivision. Merk was no stranger to northern Westchester and Putnam Counties. His family spent summers at Kirk Lake, just across the border from Yorktown in Mahopac, also a farming community. Leaving his New York City home and career in printing behind, Merk brought his wife, Josephine, and daughters, Elizabeth and Ann, north with all of their belongings in tow. This is a map of the neighborhood of Sparkle Lake. (Prepared by Robyn Prestamo, Yorktown Planning Department, 2003.)

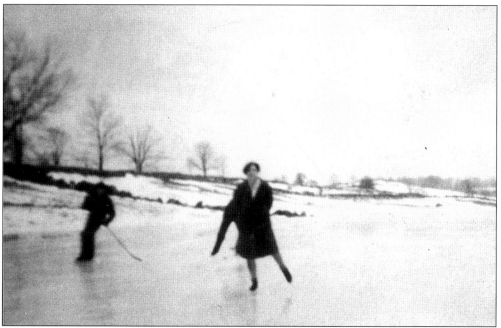

When the Merks arrived at their new home, a white farmhouse on Granite Springs Road at the mouth of Sparkle Lake, the rain had made the way so muddy that they could not get their belongings all the way to the house. "What I remember most about moving in was riding in the family car with three people sitting in the front seat," daughter Elizabeth Merk Williams recalls. "When we arrived in Yorktown, it had rained so hard that we couldn't get our belongings to the farmhouse. There were no roads in those days, so we had to store our belongings in a barn on the property. Brookside School sits at this location today. Over the course of the following week, we moved our belongings by horse, being careful to follow the ruts in the ground." Pictured are skaters on Sparkle Lake in 1926.

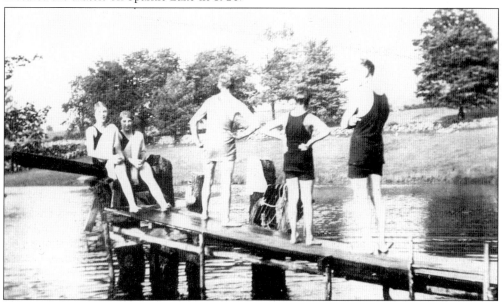

Swimmers enjoy a summer day in 1927 at Sparkle Lake. (Photograph by Elizabeth Merk.)

Over the next several years, Frederick Merk transformed this farming community into a profitable summer colony. With the help of relatives, he dammed and eventually flooded the pond. He built campgrounds and added picnic areas to his property. He sent flyers to family and friends in New York City, inviting them to spend "tranquil" weekends in the country. Hundreds flocked to this bucolic setting. A tearoom selling sandwiches and beverages was built and operated by a nephew of Merk. Shown is a brochure promoting bungalows, campsites, and daily rates for Merk Farm at Sparkle Lake.

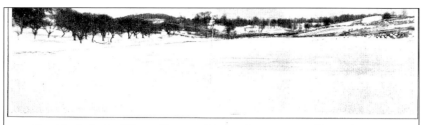

Sparkle Lake in Winter Dress, with the Orchard and Ridge Close By

MERK FARM, Sparkle Lake, is situated in one of the most restful spots of Westchester County. Any one who has ever ridden over the rolling hills and by the lakes and streams of this charming county can fully appreciate the significance of this statement.

While Merk Farm is literally buried in the woods, still it is only 2½ miles from the Yorktown Heights railroad station, its many stores, churches, fine school, and other accommodations. It is but 35 miles from the Bronx, with no ferries or bridges to cross. One and one-half hours' easy riding over very good roads brings · right to the Farm.

THERE are 165 acres of varied country. That part on the ridge overlooking the Lake will be ideally laid out for bungalows (see diagram of proposed scheme); a certain section will be devoted to camps; another part will be set aside for day visitors; still another part will be used for raising vegetables, to be sold at prevailing prices; the balance of the Farm will remain in its primitive state, a boon to the hiker and nature lover and the camper who prefers to rough it.

WE have here the foundation for one of the finest, cleanest, and most exclusive all-year bungalow sections and pleasure-grounds to be found anywhere

ATTRACTIONS

Stand and General Store.—For sale: Fresh fruits and vegetables in season; canned goods; ice, oil, and wood for fireplaces; refreshments; eggs, milk, candies, ice-cream, and soda; cigars and cigarettes, etc., etc.

The Lake.—In course of development; when completed, it will be twice its present size. Bathing, boating, canoeing, and fishing. The gently sloping shores are ideal for children and non-swimmers. Diving-boards and floats will be provided for those who care to enjoy them.

Comfort Stations.—Light, airy, roomy buildings, with ample accommodations.

Water Supply.—Chiefly from springs, the finest water any one would care to drink.

Electric Light.—At your discretion.

Delivery.—Once a day—that is, orders left one day will be delivered the next.

Garbage.—To be collected once a day.

Rubbish Baskets.—To be distributed conveniently about the grounds, with the hope that they will be used.

Tables and Benches.—To be placed in apple orchard and other desirable locations.

Amusements.—Dancing, card parties, and the usual summer activities.

Winter Sports.—Skating, hockey, skiing, tobogganing, etc.

Tennis.—Courts will be built in the near future.

PRICES

Bungalow Sites (50 x 100)...............$60 per year

Camp Sites (5 months), 50 x 100...........$40 per year
 If any part of outfit is left standing.$50 per year
 Outfits carefully stored.................$5 per year

Auto Tourists.—$1 per day; $5 per week.

Parking.—For day visitors, $1; includes use of grounds and lake, comfort stations, tables and benches, and dressing-room for bathing. Lockers and private bath-houses to be installed later.

—and, with your help, that is what we intend to make it. Elsewhere is a list of the attractions we offer you.

IF you are at all interested, don't wait until the first of July to select your site (and let us say right here that the sites are choice and will go fast) and then expect to enjoy it on the Fourth. It takes time to purchase and erect a bungalow and get things ready. Now is the time to act if you hope to enjoy a long summer of uninterrupted pleasure. After twenty years of camping—bungalow, week-end, and auto—we should know something about it. Let us help you.

ERECTION OF BUNGALOWS

WE advise the purchase of either knockdown or portable cottages, which can be erected by the lessee himself; or the management will take care of this for you. We have on file catalogues from various concerns. Shacks not permitted. We will advise and lend assistance when and where possible.

HOW TO ACQUIRE A SITE

ON recommendation only. To be passed upon by the Board of Directors. Reasonable time lease. Write for application blank to Merk Farm, Yorktown, New York.

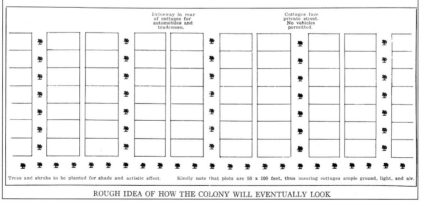

Driveway in rear of cottages for automobiles and tradesmen.

Cottages face private street. No vehicles permitted.

Trees and shrubs to be planted for shade and artistic effect. Kindly note that plots are 50 x 100 feet, thus insuring cottages ample ground, light, and air.

ROUGH IDEA OF HOW THE COLONY WILL EVENTUALLY LOOK

Frederick Merk's next goal was to build permanent homes on his land. His daughter remembers peering out of the window, across the lake, and watching her father begin construction on these homes. He had never built a house before, Elizabeth Merk Williams said, "but he was always handy." The deeds to these homes included provisions for lake rights. The first home that Clark and Joan Strang remember living in as newlyweds was a Merk bungalow. The Merk family continued to operate the recreation area until 1964. It was then sold to Mr. Feldman, who leased the property to the town of Yorktown. In 1966, the town purchased the lake and 14 abutting acres from Mr. Feldman for $59,000.

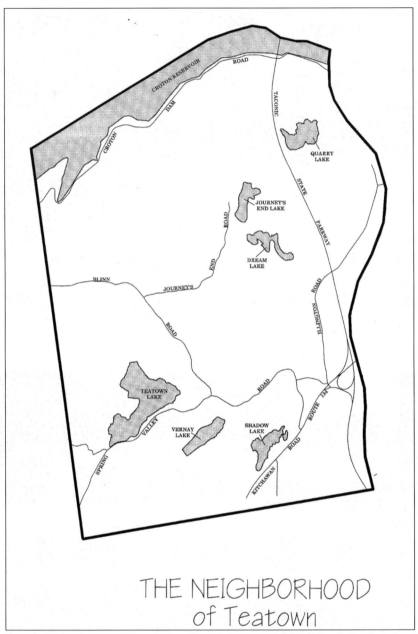

THE NEIGHBORHOOD
of Teatown

The fertile, woody landscape of Teatown, with its stream, ponds, and low hills, drew settlers from the earliest times. Native Americans of the Kitchewancs, Dutch landowners of the Van Cortlandt family, tenant farmers who eventually became farmowners, and modern residents escaping the growing population of New York City came to the Teatown area. The Kitchewancs, who lived here in longhouses, hunted and fished and cultivated gardens, moving their holdings about as the need arose. When the Van Cortlandts tended the land, they farmed it, using some of the produce themselves and shipping the rest to the cities. This is a map of the neighborhood of Teatown. (Prepared by Robyn Prestamo, Yorktown Planning Department, 2003.)

In time, the tenant farmers bought land from the Van Cortlandt heirs. One such tenant was William Palmer. The farmhouse he bought still stands in much the same state as when built in 1750 on what is now 400 Blinn Road. It retains many historic details within its walls. (Photograph by Chuck Davidson.)

Paths leading to dwellings and fields eventually became roads such as Blinn, Spring Valley, Journey's End, Teatown, and Illington Roads. Compared with these roads, today's Route 134, also known as Kitchawan Road, is wide and handles the increased traffic in this area that once saw only horses and wagons. Sundial Farm was once an inn, strategically located on the original Old Kitchawan Road that ran east to west from the Hudson River to what is now Route 100. Built in 1782, it served as a stagecoach stop and inn, with a blacksmith shop and barn for the horses. Today, the former inn is 1321 Kitchawan Road, a private residence with much the same appearance. An interesting spot at Sundial is a small cave with a tiny entrance that was a stopover site for the legendary Leather Man, an itinerant soul who wandered throughout Westchester County and Connecticut.

When General Electric president Gerard Swope Sr. came to Teatown in 1922, he reversed the practice of land division and began to add to and consolidate his holdings on Spring Valley Road. His growing family invited friends and neighbors to enjoy the splendid landscape that included hunting and fishing grounds and extensive trails through the woods. A marshy field was flooded to make a lake for boating and swimming. The reversal of land fragmentation had begun. Swope died in 1957, and his heirs transferred 173 acres of land to the Brooklyn Botanic Garden, which already had one outreach station nearby in Kitchawan. Teatown was managed by a group of directors that included two Swope family members. The reservation grew and became involved with conservation, education, and the environmental community at large. The move to independence followed in 1987, when Teatown and the Brooklyn Botanic Garden parted amicably. Today, Teatown Lake Reservation preserves almost 800 acres of natural woods, streams, and fields, with 14 miles of hiking trails and educational programs available for the general public.

"They were the Never-Turn-Back-Riders. Lucy Swope and Dottie Whitfield went riding nearly every day at the Croft, the estate in Teatown where they spent summers in the 1940s. Clad in jeans and sneakers, the friends obeyed one rule as they explored the 600-acre property: They could never turn around and go back the same way. The Swope sisters, whose grandfather Gerard Swope ran the Croft as a working farm, stayed there during the summers; the Whitfield sisters lived year-round at the estate, where their father was the farm superintendent. At the Croft, Lucy Swope and Dottie Whitfield who were not quite teenagers in the late 1940s, spent their mornings riding horses and their afternoons taking part in the activities of the Enemy Exterminating Club, known as the EEC to the uninitiated. The air would be cool when they awoke the next morning to saddle the horses, Headlight and Ginger. As they rode on trails that crossed the estate's rolling fields and woods, they'd smell the mix of leaves and dirt, and brush away damp cobwebs that broke across their faces. They'd circle the two lakes, glimpsing snapping turtles, snowy egrets and herons on the water. They'd ride without boots or helmets, and no one demanded to know where they were going or when they planned to be back. 'I think that has remained—the sense of freedom,' Dottie Whitfield Purdy said. 'I never lost the love for the animals and for the whole adventure,' Swope said. Riding horses gave them a feeling of accomplishment and possibility, freeing them from some of the constraints of the era." (Adapted from "Idyllic Summers of Childhood," by Sonia Scher, staff writer for the *Valley News*.)

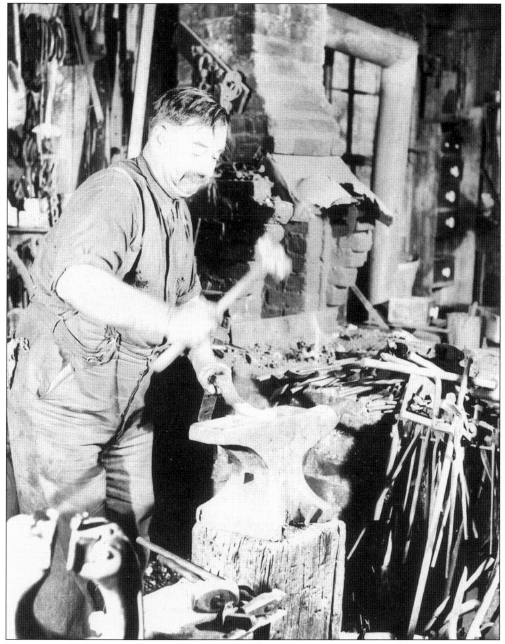
Blacksmith Chester McCord works at his shop located on the south side of Croton Lake.

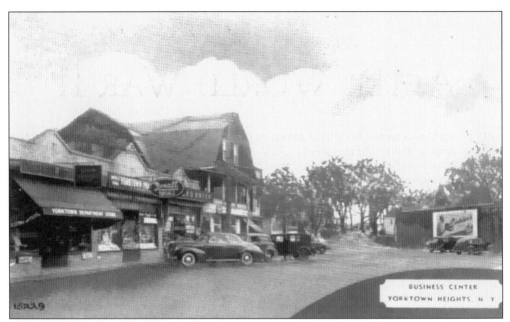

This early view shows Yorktown's business center on Commerce Street, with the Yorktown Department Store and Pharmacy (left). (Courtesy of Richard Pogact.)

A contemporary view of Commerce Street shows the business center, with the firehouse (left). Commerce Street is currently scheduled for new sidewalks, street lights, and landscaping. (Photograph by Linda Cooper.)

Twelve
AFTER WORLD WAR II

In 1947, soldiers returned from their experiences abroad to low-cost mortgages, an interstate highway system, and a changing landscape. Yorktown was eyed fondly by many New Yorkers looking for a friendly community that was "a good place to raise the kids." Many people remembered summer visits with lazy strolls by the lake and cool evening breezes, quiet forests, cows, and cornfields and yearned to live with these things every day. The summer communities had their effect; the sleepy farm towns began to become more suburban and as more people moved to the area, the sought-after idyll began to dim. Farms were sold and subdivided; housing developments were built; new schools were constructed, filled, and expanded. For several years, the school enrollment was so large that double sessions became the norm. The Putnam Railroad was still bringing passengers into and out of town. Fruits and vegetables continued to make their way from this breadbasket community to the streets of New York City. Dairy farms still thrived, and milk remained a steady export. The community revolved around the train terminal in the Heights Hamlet.

At the end of the 1950s, things took a dramatic turn. The Putnam Line closed for business. In 1958, Penn Central ran its last ride along the reservoir and through the fields of Westchester and Putnam Counties. Businesses reliant on traffic from the railroads declined. The taverns, hotels, agricultural concerns, pickling factory, and coal yard all suffered a declining demand. The homes and buildings began to have an air of past tense about them, leaving Yorktown's downtown neglected. The 1960s was a time of controversy, as the community struggled to control its future. Many businesses and homes in the Heights business hamlet were torn down and replaced by shopping centers and commercial buildings. Much of this development took place when box-style buildings and large empty parking areas were in vogue, depriving the hamlet of the Main Street charm for which many of its residents would come to yearn.

In southern Yorktown other changes occurred in the 1960s. The Thomas J. Watson Research Center, headquarters for IBM's research division, purchased more than 200 acres between Pines Bridge Road and Kitchawan Road (Route 134) just east of the Taconic Parkway. In the 1800s, the site had held working farms that exported apples to England via the Ossining docks. In the 1920s, that acreage had been used to support commercial dairies. In 1957, part of the land had been a gentleman's farm, with stables and saddle horses. IBM amalgamated 12 parcels on which to build its center, including the one owned by N. Burton Flewellen (gentleman farmer, justice of the peace, and former town councilman). World-renowned architect Eero Saarinen designed the research facility in a crescent. The 74-degree arc was intended to blend the building with the terrain, following the configuration of the hill, so that it would be harmonious with its natural surroundings. Saarinen died shortly before the dedication ceremony in April 1961.

The Watson laboratory began at Columbia University as a collaboration between IBM and the university. The new facility was designed to carry out "scientific research where the problem is dictated by the interest in the problem and not by external considerations," according to laboratory director Wallace Eckert. With corporate funding, the opportunity arose for one of the first applications-oriented research operations weighted toward pure science. The new facility drew to Yorktown nearly 2,000 scientists and technical workers, many of whom brought families with them. Their children swelled the four school districts included within the boundaries of Yorktown: Croton, Lakeland, Ossining (the facility lies within the Ossining School District boundary), and Yorktown.

The Brooklyn Botanic Gardens also came to the area in the 1960s. It opened an outreach research center down the road from IBM on a parcel formerly owned by the Van Brunt family.

In 1963, it received a gift of an additional 173 acres from the Swope family. The parcel just west of IBM, now Teatown Lake Reservation, began as an outreach station. Teatown, which is now independently incorporated, has more than 700 acres of nature preserve and an environmental education center. Its presence ensures the natural beauty of the area for future generations.

In 1953, Yorktown commissioned a master plan, noting that the population of the town had more than doubled within five years. Frederick P. Clark, planning consultant, noted that "the community is changing form a sparsely settled farming area to a residential section for persons working in New York City, southern Westchester and other employment centers within driving distance of the town. Old landmarks are disappearing or changing beyond the recognition of older residents." In 1955, the master plan report noted that Yorktown's population in 1920 was just 1,441 people and that the town had grown as Westchester County had developed into a residential haven for commuters to New York City, as well as for those looking for pastoral summer residences. The popularity of the automobile and the growth of the county parkway system meant that by 1940, there were 3,466 year-round residents, and that by 1950, there were 4,731. In the 1950s, a number of the summer residences were converted to year-round homes, except in the Mohegan Lake area, where the summer community continued to thrive. Most of the town's population settled along Crompond Road and Gomer Street. According to the 1950 census, the town's labor force fell mainly into the categories of laborer, craftsmen, foreman, managers, and proprietors, with a smaller proportion in the professional, technical, and service classes. The rate of growth in the 1950s was enormous by current standards. It was projected that by 1975 there would be between 25,000 and 43,000 residents. The plan turned out to be fairly accurate. In the early 1970s, the social and economic shifts of the previous decade had altered the development prospects of the region. Until then, the population of northern Westchester had been increasing at a rapid rate and the trend of continuing growth was never seriously questioned. During the 1970s, Westchester's population declined and continued to decline into the 1980s, as policies of conservation and protection of existing land and resources replaced new growth.

The 1980s heralded the development of condominium communities, mixed-use neighborhoods (single- and two-family homes), and cluster housing—designed as affordable housing for the middle class, the bulk of Yorktown's population. More ball fields and service requirements followed, as the town approached the millennium. The community began to recognize the limits of its infrastructure and road capacity. Development took the focus of improving the appearance and effectiveness of the five business hamlets. Railroad Park was renovated, along with Shrub Oak Memorial Park, which included an in-line hockey rink and ball fields, as well as an aquatic facility. A water-filtration plant was constructed in partnership with neighboring communities, and local waterworks took over from the county the operation of the Amawalk Plant. Sewer issues rose to the fore, as homes built years ago on small lots reached their saturation points. Road capacity was also an issue, as money was requested to reconstruct Routes 202 and 6, along with the Bear Mountain Parkway.

The town's path has wound its way from playing a key role in the Revolutionary War, through being the agricultural breadbasket and milk bar for the surrounding area, to serving as a summer colony, to becoming a community of thriving retail businesses and individuals who have carved out their homes in this northern suburb of New York City. Currently, the town is developing a new comprehensive plan, with goals that include the maintenance of shoreline beauty, the creation of architectural overlays to define a sense of place in the business hamlets, the installation of traffic-calming devices integrated into local roadways to keep the automobile from becoming more important than people, and the preservation of the area's history and landmarks. The community looks to the future as it remembers, marvels over, enjoys, learns from, and incorporates the lessons and memories of its past.

—Linda Cooper

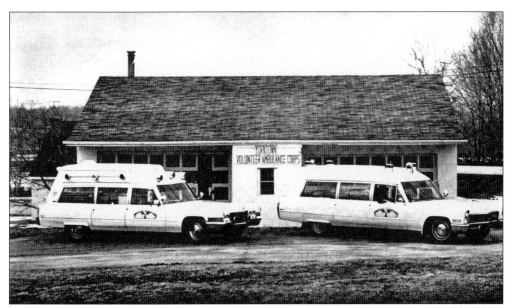

The Yorktown Volunteer Ambulance Corps is one of two volunteer corps serving the Yorktown area. Volunteers embody the spirit upon which this community has been built.

Professional services have replaced the lumberyard, pickling factories, and agriculture-based businesses that grew up around the railroad line. This is a photograph of the Courtyard at Underhill Avenue, where professional offices and a restaurant are located.

This historic marker is located in front of Yorktown Town Hall on Underhill Avenue. Yorktown was incorporated in 1788 along with 21 other towns in Westchester County in order to allow landowners to vote closer to home. (Photograph by Nancy Augustowski.)

Over time, place names and people change within a community. Yorktown has had several name changes, as well as street names and the use of many of its buildings. As an example, the Old Yorktown Methodist Church (left) is now the Temple Beth Am.

Contributors

Nancy Augustowski, a 55-year resident of Cortlandt, is a staff member of the Yorktown Museum. A photographer, artist, and collector of dolls and postcards, she has been affiliated with the museum since 1974.

Jean Cameron-Smith, a former Teatown Lake Reservation trustee, chairs the Teatown History Committee, which put together *Teatown Lake Reservation*, published by Arcadia in 2002 and reprinted in 2003. A Yorktown resident living in the Teatown area, she is a real estate agent, writer, and business owner.

Susan Chitwood is a freelance writer who writes about local history and the arts. A resident of Cortlandt Manor, she is the former editor of the *Peekskill-Cortlandt Herald* and the *Star*.

Linda Cooper was elected supervisor of Yorktown in November 1995. A 35-year resident of the town, she has been a living witness to the expansion and growth in the community. She is a frequent speaker at regional and statewide forums on environmental and government issues. As a former journalist, press secretary, corporate public relations professional, and certified planner, she developed an interest in the history of many places, particularly Westchester, and enjoys sharing that history with others.

Lincoln Diamant, a Yorktown resident for 35 years, was the first president of Teatown Lake Reservation. He has written five books on the history of the Hudson Valley during the American Revolution.

Monica Doherty, a 48-year resident of Yorktown, is a past president of the Yorktown Historical Society who is currently a board trustee serving as program coordinator. She is also is a member of the Material Archives and Laboratory for Archaeology (MALFA). As a field-trained archaeologist, master gardener, and charter member of the Yorktown Beautification Committee, she enjoys reading and writing about local history.

Stuart Friedman is the chairman of the Yorktown Museum Board. A Yorktown resident since 1986, he is a specialist and scholar of 20th-century art, centering on the lesser known artists of the New York School of Painters. As an independent curator, he has put together two art exhibitions entitled "Connie and Wally" and "Made in Yorktown: 40 Artists of Quality." As a photographer of art, he has worked on more than 30 books and catalogs.

Adele Hobby is the assistant curator of the Yorktown Museum. A 43-year resident of Amawalk, she lives in a home that was part of the Amawalk Nursery.

Sophie Keyes is the *Saw Mill River Audubon Newsletter* editor and historian. A former Teatown trustee, she has lived in the Kitchawan area of Yorktown for 36 years.

John T. Martino, author of *Yorktown at War 1775–1783* and of a comprehensive history of Yorktown during the Revolution, graduated from Yorktown High School in 1970. He is currently the director of government affairs for the Pennsylvania Turnpike Commission and resides in Lancaster, Pennsylvania.

West Moss is a writer and editor who grew up on Teatown Road in Yorktown and still lives in Westchester County. She currently works for the Ossining School District.

Carl Oechsner, a local historian, writer and lecturer, produced the Arcadia histories of the towns of Croton-on-Hudson and Ossining. As a local social studies teacher, he instilled a love of American history in hundreds of children and brought history to life for many area residents.

Dolores Pedi, a volunteer at the Yorktown Museum, grew up in Westchester and has lived in Yorktown for the past 20 years. She is a charter member of the Taconic Postcard, and one of her hobbies is collecting old postcards of the area.

Robyn Prestamo, a Mahopac resident, is an assistant planner with the Yorktown Planning Department.

Alice Roker, has been town clerk for Yorktown since 1990. A former Emmy Award–winning producer of WNBC TV's News Center 4, she resides in the Sparkle Lake area of Yorktown with her two children, Gregory and Courtney.

Nancy Truitt has resided in Croton Heights since 1973, when she and her husband moved from Lima, Peru. She has served as president of the Croton Heights Community Association and heads its committee on development issues. A foundation executive, she has her own economic development consulting firm.

Otto Mayer Vondrak has had an interest in Westchester's railroads since the age of five. Born and raised in Katonah, he is an author on various railroad subjects and a graphic designer and illustrator. In his spare time, he is a Scout troop leader.

Barbara M. Walker, a writer living on Spring Valley Road in Yorktown, has also lived on both Allapartus Road and Illington Road. Her sources for her essay on Yorktown's theater district are the Internet Broadway Database, the Ossining Historical Society, and personal papers from her service as a Wiltwyck School Board member.

This waterfall is located at Hallock's Mill, which from the mid-1800s to the early 1900s was a post office designation. It included a gristmill, sawmill, blacksmith shop, wheelwright shop, and in the Hallock's Mill House, the post office and a private school. A powerful stream was necessary to furnish power from the mill wheels to grind grain for flour and feed for stock. Power was also needed to run the sawyers' belts for the lumber to build houses and barns.